Painting seascapes

John Raynes

Studio Vista, London
Taplinger/Pentalic, New York

First published in the United States in 1980 by
TAPLINGER PUBLISHING CO., INC.
New York, New York

Printed in Holland

Library of Congress Catalog Number: 79-56607
ISBN 0-8008-6205-8

Painting seascapes

Contents

Fig. 1

Introduction

Painting seascapes is unusually demanding and challenging, because the sea moves and changes colour with great speed and variety. Water reflects the changing sky and interacts with it, in a much more immediate way than do most landscapes.

The sea's form is never constant; it can assume the appearance of a plain or of a mountain range, and is rarely still enough to be observed and drawn objectively, in the way that one can deal with land forms. The continuous impact of the mobile sea on the rigid land edge produces diverse shorelines, which are changing and evolving much more rapidly than inland earth contours. It is here at the sea shore that the most rapid laying-bare of geological history is occurring. Most of us live on the soil or road-covered surface of the land, and only where rivers or glaciers or the sea have made an incision do we see what underlies the benign slopes. Cliff strata give evidence of cataclysmic forces and pressures, which often belie the relatively calm forms sloping to them. For me this revelation of natural forces gives to sea and shorescapes an immediate and elemental quality rarely found inland. Most people at some time feel a sense of awe at the sight and sound of the ocean, even from the safety of the shore, and the huge blocks of stone dumped onto promenades after spring gales can leave no doubt about its power.

I realize of course that the sea can also mean a gentle lapping on soft sand, and paddling and sand castles and ice cream; and that this is an aspect which is just as valid, just as expressible in painting as the more robust moods. However, I believe that the more one has to do with the sea the more respectful of its latent power one becomes, and that if the essence of the sea is searched for in the shapes of the stones and rocks, the shales, even the sands, that are formed by it; in the structure of boats designed to sail on it, and of anchors and anchor chains and breakwaters and jetties, one is inescapably led to an idea of awesome power rather than prettiness.

Therefore I do not intend in this book to talk much about the seaside as a resort, fascinating though this may be in its own way, but to suggest that you try to discover that essence of the sea which is independent of humanity. The sea was here long before us, and will doubtless still be here when we are gone. It is this total immunity from man's control (except for a few dykes and sea walls that are soon destroyed unless constantly renewed) that

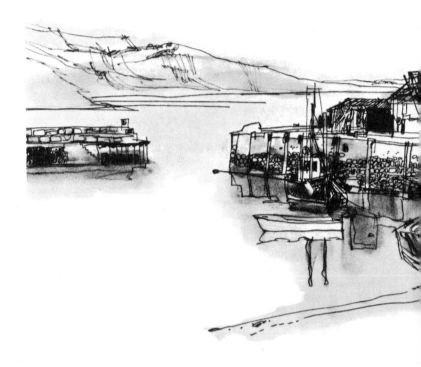

I find fascinating and would like, if only I could, to express in drawings and paintings. It is comparatively easy to talk about, quite a lot more difficult to put down in paint, but there are clues and certain practical procedures which simplify the activity and make it possible to concentrate fully on the meaning without too much struggle with the method. It is in these aspects that I will try to be helpful.

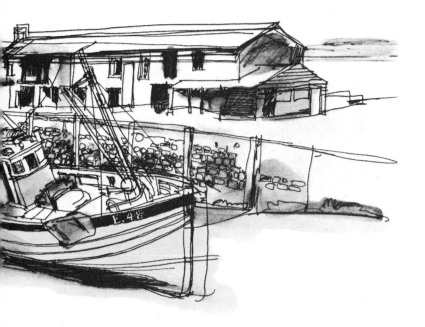

Fig. 2 Calm day at Lyme Regis, Dorset

Equipment and materials

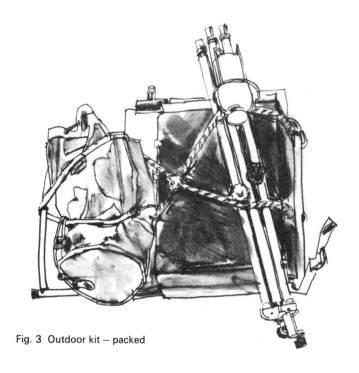

Fig. 3 Outdoor kit – packed

When discussing the equipment necessary for the special subject of seascape painting, the assumption will be that a great deal of work is to be undertaken outdoors, some way off the beaten track, and quite possibly in arduous and exposed conditions.

Apart from the unique requirements of such possible conditions, the equipment will be much the same as for any other outdoor painting. In my books in this series – *Starting oil painting* and *Starting to paint with acrylics,* I described basic requirements for painting on location; and I must apologize to readers of one or both of these books for covering some of this ground again.

Over the page (pp. 12–13) is a diagram in which I have tried to summarize the minimum recommended requirements for paints, brushes, medium and surfaces in the three media mainly used – oils, watercolours and acrylics – and in fig. 6 you will find sugges-

tions for a reduced kit for drawing. I have included a small range of waterproof coloured inks in this latter, but they could equally well be included with watercolours or even acrylics, although they do not always mix too well with acrylic mediums and are normally repelled by the plastic paint. They do serve very well as an underpainting though, and acrylics can be used over them without problems.

The choice of media for seascape painting is a personal one of course, but it does seem to me more sensible and convenient to use water-based paints for general use outdoors. Water is easier to carry and, of course, to replenish; the paints dry quickly to allow underpainting and overpainting several times in a day's painting, and the paintings are easy to carry home. Cleaning up brushes, palette (and self) is rather easier too, and in my experience an oil kit is usually rather heavier to carry, although I suppose this is not necessarily always so. Acrylic paints can be used in a similar way to oil paints anyway, and it is difficult or impossible to tell the difference in a completed painting.

Two points in favour of oils on location: 1. the very fact that they dry slowly can be useful if you like to move the paint about and paint wet in wet; or for hot conditions, when the drying of acrylics is accelerated so much that they solidify on the palette before you have had a chance to use them, and 2. they can be used in the rain. This may seem a doubtful advantage, but sometimes one is subjected to a gentle shower or just a few drops of rain or sea spray — not enough to have to shelter oneself, but very damaging to a water-based painting — even acrylics which dry quickly can be affected to a limited extent, only the very freshly applied paint being vulnerable. It does happen, rarely and luckily, that rain drops on a watercolour drawing produce an exciting improvement, but this cannot be relied on!

Indoors in the studio, when weight and drying time are not such vital factors, the choice of paints is even more a matter of personal taste, and at some time perhaps all should be experimented with — not all in one painting, I might add. Although this is possible, there is no special advantage in mixing media to this extent, and the problems involved are unnecessary.

Having decided whether oil or water-based paints suit one best, it is as well, I think, to equip oneself comprehensively with one or the other, rather than with dribs and drabs of both. This

Fig. 4 COLOURS		MEDIUMS
OILPAINTS	**Permanent rose** **(Quinacridone)** **Cadmium red or less expensive equivalent** **Cadmium orange or less expensive equivalent** **Aureolin or azo yellow** **Lemon yellow or hansa yellow** **Winsor emerald** **Winsor green (phthalocyanine)** **Cerulian blue** **Ultramarine blue** **Winsor blue (phthalocyanine)** **Winsor violet or dioxazine purple** **Raw sienna** **Raw umber** **Burnt umber** **Ivory black or mars black** **Flake white** **Titanium white**	**Turpentine** **Linseed oil**
WATERCOLOURS	**Permanent rose (quinacridone)** **Scarlet lake or cadmium red** **Cadmium orange** **Gamboge or cadmium yellow** **Winsor green** **Cerulean blue** **French ultramarine (blue)** **Winsor blue (phthalocyanine)** **Permanent mauve or winsor violet** **Paynes grey or neutral tint** **Raw sienna** **Burnt umber** **Blue black**	**Water**
ACRYLICS	**Cadmium yellow, permanent yellow or azo yellow** **Permanent rose (quinacridone)** **Cadmium red or naphthol red** **Cadmium orange** **Lemon yellow or hansa yellow light** **Yellow green (called by a great variety of names)** **Winsor or monastral green (phthalocyanine)** **Peacock blue or Turquoise** **Ultramarine blue** **Winsor or monestial blue (phthalocyanine)** **Spectrum violet or dioxazine purple** **Raw sienna** **Burnt sienna** **Raw umber** **Permanent white (titanium, opaque)** **Flake white (relatively transparent)** **Ivory black or mars black**	**Water** **Acrylic** **mediums, gloss** **and/or matt** **(matte)**

BRUSHES	SURFACES
1-in. bristle house-painting brush No. 10 filbert hoghair (bristle), long No. 12 flat hoghair (bristle) No. 8 (two of these) filbert hoghair (bristle) $3/8$-in. flat ox and sable No. 4 round sable No. 2 round sable	Canvas Primed board or wood panel Oil-treated paper
1-in. flat or No. 10 round: squirrel hair wash brush $1/2$-in. flat pure sable $1/8$-in. flat pure sable No. 6 round sable No. 3 round sable	Handmade paper – rough or smooth surface, mounted on board or stretched
1-in. flat oxhair $3/8$-in. flat ox and sable $3/16$-in. flat sable $1/8$-in. flat sable No. 2 round sable No. 4 round sable	Smooth-coated paper mounted on board Handmade paper smooth or rough Primed hardboard, canvas or almost anything

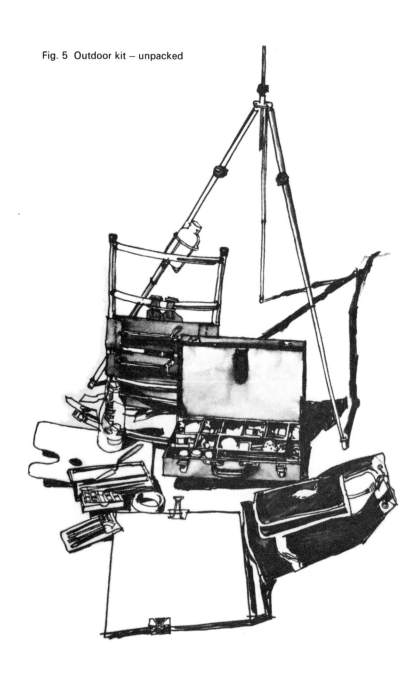

Fig. 5 Outdoor kit – unpacked

Fig. 6 Black and white kit

applies especially to the outdoor kit, where compactness and complete self-sufficiency are essential. As I have described in other books, the type of painting case I find to be most useful is one with compartments into which one can drop groups of colours – i.e. one box for yellows, one for blues etc. – good deep compartments into which tubes can be dropped or thrown, not requiring careful placing. Manufactured paintboxes, displaying tubes of paint arranged in a long neat row, I view with little enthusiasm. What happens when the tubes are partly used and folded up? They do not sit in their neat little moulded depressions any more, but lie about in unidentified heaps. Colours take vital irritating extra seconds to find, and such small deterrents as these are often enough to persuade one almost unconsciously to use a colour already out on the palette instead of finding and squeezing out new clean colour. Just recently I saw a box which a student had discovered in a sports' shop, surprisingly, which was adapted splendidly for use as a paint and materials case. Its designed use was as a fisherman's holdall – for hooks, flies and whatnot I suppose – and I have drawn it in fig. 7. Although the compartments are not as deep as I would like, the three trays plus the deep box at the bottom allow for a good deal of easily-maintained separation of colour groups, and everything is very easily and immediately available. This of course is the whole point – the painting is the important thing, what goes down there is what matters, and the less time and attention given to the mechanics of painting, the

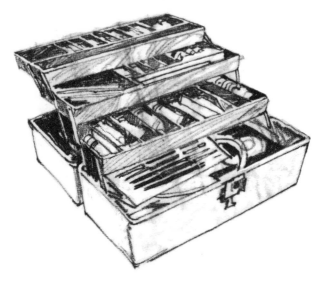

Fig. 7 Equipment box

more attention can be focussed on the painting itself. Good equipment will not ensure a good painting, but inaccessible or incomplete equipment militates against producing a painting at all.

The basic painting case, in addition to paints in colour groups if possible, should have room for water or turps/oil container, and for brushes, palette knife, mediums, canvas pins or tacks (if oils are used – for keeping wet paintings apart), rag, and various useful oddments such as razor blades, trimming knife, sticky tape, drawing pins (thumbtacks). Bulk water or turps supply is usually better carried separately. I use a small duffel bag for this, and for camera, drinking water, food, spare pullover and anorak. Painting surfaces and palette can be clipped together, and a lightweight folding easel completes the equipment. A folding stool is very useful, but I do without one, and usually manage to find a reasonably comfortable perch. It could be argued that a stool is more useful than an easel for seascape painting, as the winds on cliff tops and sea fronts are often too severe for any folding easel to withstand. In gale force winds, I have had to hang onto my drawing board as hard as I could with *both* hands to avoid its being torn from my grip

Fig. 8

Fig. 9 Easels

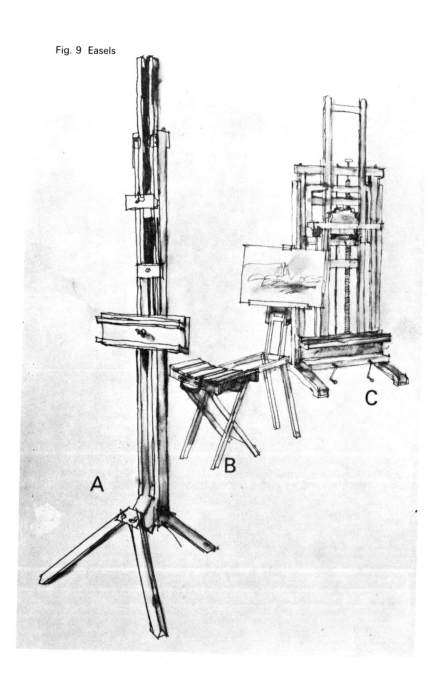

by sudden gusts, only releasing one hand to paint with in the lulls between. I have never tried it, but perhaps some sort of strap fastening the board to one's knees might be useful in trying conditions – a comic image, but if effective, who cares?

Rain and spray can also make sea painting a problem, but if you are really seriously concerned to learn about the sea, you have to be prepared to get a little wet. It is essential to realize that conditions by the sea can change rapidly, and to be equipped for the worst. Even on a hot summer day it is worth taking a wind and waterproof anorak or similar garment, and at any other time of the year a thick sweater too. Sitting for two or three hours in even a light sea breeze dissipates body heat surprisingly effectively!

Having collected the equipment into three basic packages – paintbox; surfaces, palette, easel; and duffel bag for everything else, it is really best to put the whole lot on a carrying frame. I use one as illustrated in fig. 5, and fix everything to it with elastic straps. Although the paintbox alone weighs 20 lbs, once on my back the whole lot is quite easy to carry, and it is no problem to walk a few miles, and clamber over rocky or stony beaches.

With the reduced kit (using only monochrome), the carrying frame is so lightly laden that it can almost be disregarded, and it is possible to negotiate quite rocky foreshores – or even steep cliffs, if you are a better climber than I am.

It is not only that weight is easier to carry on one's back, it is equally important that it leaves the hands free, making rock clambering very much easier and safer.

I have also used the unloaded carrying frame as an improvized seat on rough surfaces, so altogether I consider it to be a worthwhile, even essential, part of outdoor painting equipment.

Indoors, the only additional equipment needed is a more substantial easel. Sketching easels will do, but are not ideal, especially if you intend to work on rather larger paintings. Most lightweight easels will not hold a painting rigidly over a size of about 20 by 15 ins. A radial easel (illustrated in fig. 9) is fine for up to about 30 by 40 ins, if the surface itself is rigid. Larger paintings, if they are higher than they are wide, can be held satisfactorily, but if much wider than about 40 ins they really need a studio easel (type C in fig. 9). Some painters use two radials side by side for very wide paintings (fig. 10).

Fig. 10

Monochrome kit

1 Inks: waterproof black, brown, yellow
2 Paints: acrylic black, acrylic opaque white;
 gouache jet black, flake white (transparent), raw sienna
3 Brushes, black felt-tipped pens, pencils in various grades,
 two pens — fine and broad
4 Surfaces and palette
5 Water bottle and pot
Surfaces and palette clipped together, everything else in duffle
bag.

Full colour kit

1 Paintbox: paints, mediums, brushes, palette knife, pencils, pens,
 ink, trimming knife (mat knife), razor blades, rag, sponge,
 sticking tape, pins (both canvas tacks and thumbtacks)
2 Painting surfaces: various, clipped together
3 Palette
4 Water or turpentine: for replenishing water pot or dipper
5 Portable easel with water pot attached
6 Carrying frame
7 Duffel bag: camera, drinking water, food, spare pullover and
 anorak (parka or windbreaker).

20

The colour of the sea

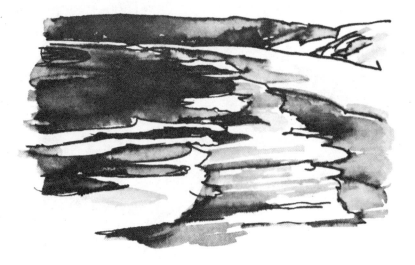

Fig. 11 Sketchbook notes

Sea and sky, to people who do not often look, are always blue. The truth is that only if the sky is blue will the sea be blue also. The two are interdependent: the sea is a great mirror of the sky, and is constantly changing as the sky changes. It can be almost any colour in fact, but is most often seen in the green-blue hue range.

To explain what is meant by 'hue' and to discuss colour further, it is first necessary to talk about colour theory a little.

The components of sunlight can be split into the visible range known as the spectrum. Although these components are usually named as red, orange, yellow, green, blue, indigo, violet, it is really an infinitely subtle gradation through all these colours. One thing they all have in common is that they are pure and unadulterated by black or white; there are no greys, browns, pinks or ochres. When I use the term 'hue' I mean it to refer to a point in this pure spectral range.

A colour which is not in itself of the spectrum can be described, and indeed mixed, by identifying its basic hue and then adding white to adjust the concentration of hue, and black to adjust the tone. To mix by this method successfully it is obviously necessary

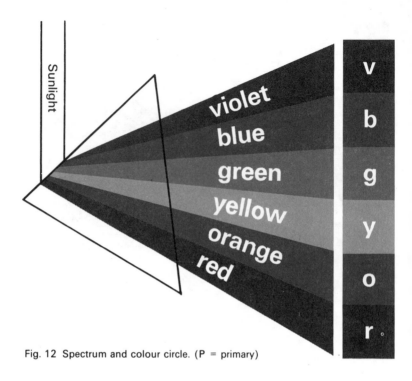

Fig. 12 Spectrum and colour circle. (P = primary)

to get the hue *exactly* right, and although it is not possible to have paints representing every infinitely subtle gradation of the spectrum, we can choose a range from which they can be mixed. Pigments are not colours in themselves, they are substances which have a particular colour, and which retain that colour when mixed with a vehicle or medium — such as oil, gum or acrylic — which allows us to apply them as paint.

Many of these substances are not a bit like spectral colours — the earliest and still some of the most permanent pigments were the 'earth' colours made from coloured clays, mostly in the yellow-brown range. Luckily though, pigments such as carmine (cochineal), vermilion (mercuric sulphide), ultramarine (lapis lazuli), chrome yellow (chromate of lead) are nearer to colours of the spectrum, and theoretically it should be possible to mix any hue using only red, yellow and blue. In practice, unless these three primaries are very carefully chosen and very pure, it is not possible to mix the whole spectrum.

Modern colour printing, using a combination of magenta (a pink-red completely devoid of orange), cyan (a slightly greenish blue), and process yellow (pure, strong mid-yellow), plus black,

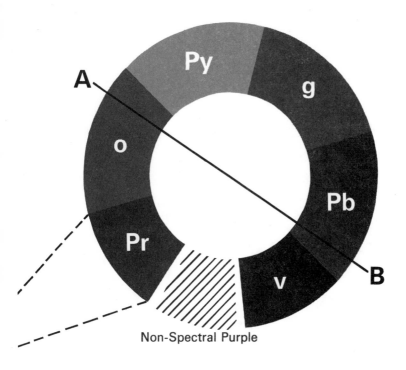

Non-Spectral Purple

makes a pretty good job of imitating all the colours of nature. For painters it is easier to supplement these three primaries with hues midway between them, i.e. a clear mid-orange (between red and yellow), a strong green (between blue and yellow) and a violet (between red and blue).

These colours are called secondaries, as they are theoretically obtainable from mixing the primaries, and they are placed in a colour circle between their component primaries and opposite the third primary as in fig. 12. The colour circle, you will have realized, is just a simplified spectrum bent round on itself, the purple (which is not of the spectrum) being added to join violet and red together and complete the circle. Colours opposite each other in the colour circle are called complementaries; thus yellow is complementary to violet, green to red and blue to orange. A fact that is often overlooked is that this holds true for all the intermediate hues too. Any straight line through the centre of the colour circle will link complementary pairs: referring to fig. 12 again, the line AB links a yellow-orange with a cold blue, say ultramarine. Complementary pairs of colours are very useful, because they have the peculiar quality of reacting with each other if placed close together and

23

Fig. 13 Warm palette layout

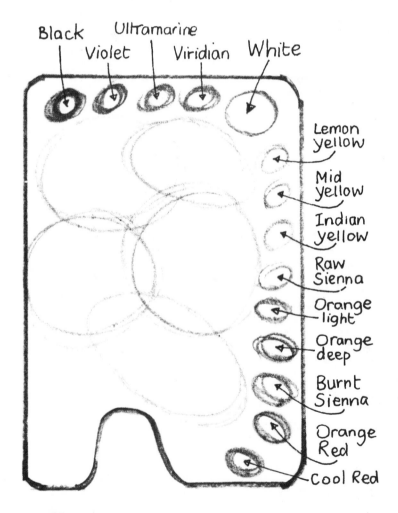

Fig. 14 Cool palette layout

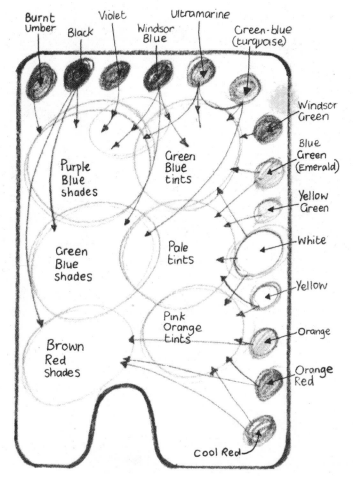

Fig. 15 Kilve cliffs, North Somerset

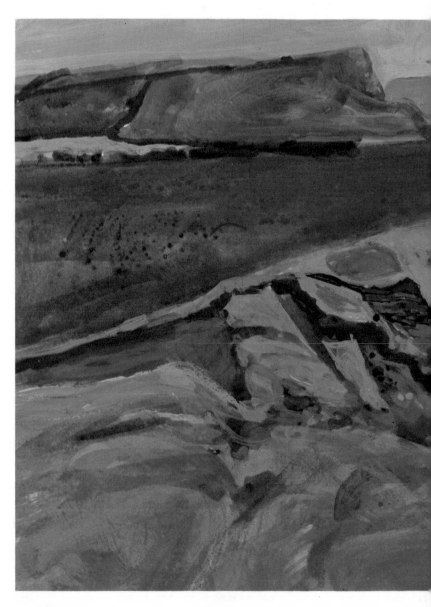

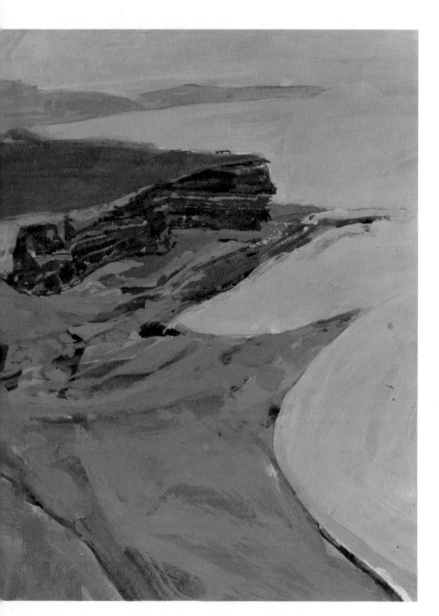

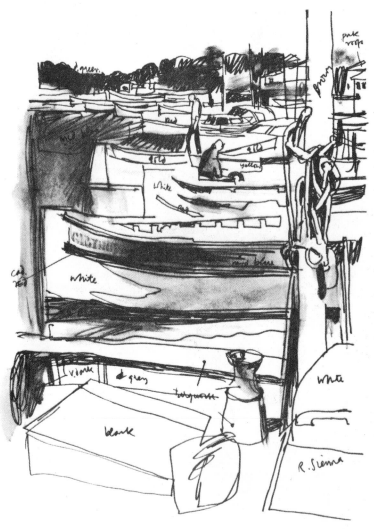

Fig. 16 Colour notes

causing a little vibration to occur between them, sometimes only mildly registering as a strong colour contrast, but with some colours, notably reds and greens, producing violently dazzling effects. Painters began to see this phenomenon consciously only relatively recently, from the late nineteenth century in France, when much experimenting with the science of colour was being pursued. If you are interested in these aspects, look at the work of the French Impressionists, the Pointillists especially and the

Fig. 17 Gradated greys

Fauves — a French post-impressionist movement — and also the work of Paul Gauguin. He was not a marine painter but he made great use of the tension between complementary hues in his colour compositions. So also do the so-called 'Op-art' painters, who set out to disturb and deceive the eye, to create movement, dazzle or even nausea, simply from the juxtaposition of abstract shapes and colour.

I have chosen the colours listed on pp. 12–13 by balancing the ease of obtaining any colour you wish by minimum mixing, against the expense and encumbrance of too massive a collection. You *could* work with less, but I think it would be unnecessarily restricting. I personally keep a vast range of colours in various types of paint, so that I can choose a working range with a bias towards a certain colour key. By colour key I mean a sort of 'home' colour or group of colours, which one starts off with when doing a colour composition. Although many other colours may be introduced, they are chosen in relation to the 'key', either by harmonizing with it or consciously kicking against it. I think it is important to have a positive colour idea of this sort. Otherwise the painting becomes either entirely descriptive and a slavish imitation of what is seen, which will probably not really be as it is (and a camera does it better anyway); or, while striving for a personal interpretation, too many colour ideas are used and the painting becomes disorganized and fragmented. Too many colours, too many ideas, without any feeling of complete 'oneness' — a very common fault. It is really best to keep the elements of a picture simple and working together, adding more complications if you wish as your organizational competence increases. For myself, I prefer the simple solutions anyway. Look at the De Stael (fig. 78) and the Christopher Wood (fig. 74) — such simplicity, but the very essence of marine atmosphere.

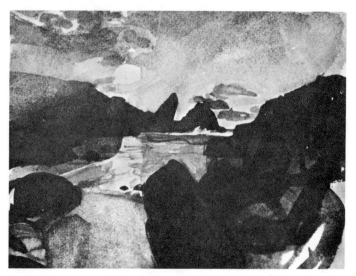

Fig. 18 Sunset — wash drawing

A great help in keeping the colour of a painting under control is a system of palette layout. Certain colours (such as orange and orange-reds) are thought of as warm colours, and blues and blue-greens are fairly obviously cool. In fact it becomes quite useful to divide all colours into warm or cool categories. Thus violet, through purplish blues, ultramarine, green-blues, blue-greens, mid-green, yellow-greens, and perhaps greenish yellow constitute the cold to cool category; and mid-yellow through orange-yellow, yellow-orange, orange, orange-reds to bright reds, are in the warm to hot category. This classification leaves the pure magenta red in a slightly ambiguous position — it is a very cool red, but *as* a red it belongs in the hot category! The slightest amount of yellow added, and it is a flaming hot red, while a small amount of blue transforms it into a cold violet or purple. I treat such a pure pink-red as a useful link between hot and cold. All colours which are admixtures of cool colours will be cool also; and similarly, warm colours mixed together never go cool. Add to this the fact that adjacent hues in the spectral range harmonize with each other, and when mixed together produce a very clean intermediate hue, and it becomes apparent that a palette layout based on spectral order and colour temperature will make for cleanest mixtures and greatest order. In figs 13–14 I have drawn suggested palette layouts employing these principles. The cool layout only differs from the warm one by virtue of the extension of the blue-green range of colours in the cool layout, as against the

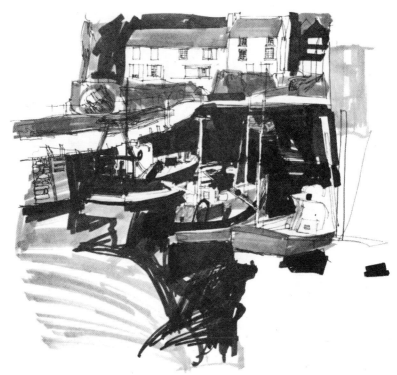

Fig. 19 Polperro, Cornwall — felt-pen sketch

orange-red extension in the other. Browns, ochre and sienna *can* be mixed by addition of black with spectral hues, but most people prefer to include them in the working range. I think it is a good idea, they are beautiful colours, especially raw umber and sienna, and it takes a lot of fiddling about to mix them satisfactorily. Their position on the palette in this system is slightly tricky, but I usually place ochre and siennas with the warm yellow-oranges, and the browns somewhere close to black. Even if your intention is only to use a very limited range of colour, the palette order should be so habitual that the paints are still placed in their full-palette layout positions.

If colours are mixed on spaces on the palette somewhere between the mixed colours or adjacent to one of them, the mixing areas tend to adjust themselves into four groups. Close to white on the cool side will be an area of cool tints, and on the other side, warm tints will predominate. Near to black will be cool blue and purple shades, and warm red and orange shades. (Tints are hues to which white has been added; shades are hues with black

31

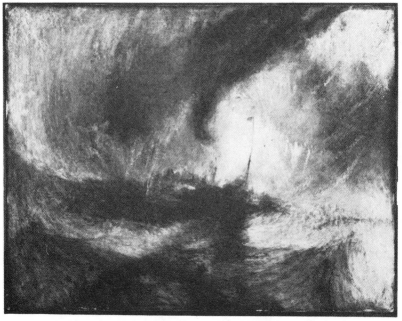

Fig. 20 *Snowstorm* by J. M. W. Turner. Tate Gallery, London

admixed). The mixings will not remain this orderly for long: as the space is used up, mixings tend to roam all over the palette. When it gets so crowded that accidental bleeding over from adjacent mixings occurs, or if it becomes necessary to mix over other dry or semi-dry paint, then it is time to stop, clean off the palette and start fresh.

It may be thought that I am stressing this matter of palette order unduly, and that such orderliness would be inhibiting. The contrary is true I believe; although it takes some time to describe the procedure, it takes no less time to place colours haphazardly than to put them down in a habitual order, and the habit of mixing clean intentional colours, once formed, actually saves time and leaves you freer to think about the painting itself.

Assuming that you now have a good complement of colours laid out in order on the palette, it might be as well to list some of the possible mixtures available by direct admixture of two pigments. I am often asked, even by art students (who should know better), how to match colours, and it is worth taking a little time experimentally mixing colours together in varying proportions, noting the result and then perhaps trying to match it by choosing a hue

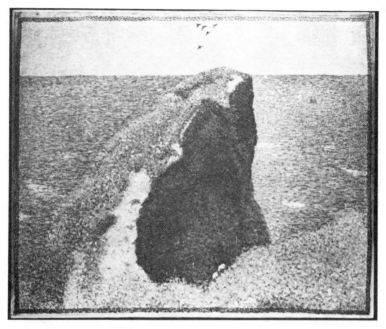

Fig. 21 *Le Bec du Hoc, Grandcamp* by G. Seurat. Tate Gallery, London

and adding black and/or white. You will soon develop the ability to look at an admixture and say what needs to be added to it to match a required final result. As a general guide here is a short selection from the infinity of possibilities:

Black plus a little cadmium yellow	=	dark olive green
Cadmium yellow plus a spot of black	=	lime green
Viridian plus raw sienna	=	light olive green
Viridian plus a little orange	=	mid-olive green
Viridian plus a little cadmium red	=	rich dark green
Burnt umber plus lemon yellow	=	raw sienna
Orange plus a little viridian	=	variant of raw sienna
Cadmium red plus a spot of viridian	=	rich mid-brown
Cadmium red plus ultramarine	=	inky mauve
Ultramarine (blue) plus a little orange lake	=	brownish purple
Ultramarine (blue) plus orange lake	=	mid-warm brown

Of course there is a great deal more that can be theorized about colour and colour mixing, and if you are interested to pursue the subject further, there is a book in this series devoted to the subject, *Colour for the artist* by Hans Schwartz.

33

Just as important as being able to put down the colour intended, is the ability to make decisions about the colour of the world about us. To return to the subject with which I began this chapter, the colour of the sea, there is no one answer to this. Observation is the thing: *really* looking I mean, without preconception. While observing, make notes (colour sketches if possible, but otherwise a drawing with written notes), to record colour sensations. Look carefully at the way the sea colour changes from foreground to horizon — are the changes due to variations in clarity of the water or are they alternate bands of sunlight and cloud shadow? Is the sea darker or lighter than the sky at the horizon, or exactly the same? When making colour notes of sky and sea, where everything is on the move and changing from one moment to the next, it is probably easiest to do quite small — almost thumbnail — sketches. It is not necessary to completely cover the surface either — a dab of carefully-chosen colour can be used to denote the colour of a complete area. The definition of the limits of the area can be made after the colour has been noted, or even later, as it changes. Think of the exercise as the gathering of information rather than the creation of a work of art, so that it does not matter what it looks like as long as it contains genuine discoveries that can be put to use at greater leisure. I often find such fragmentary note-taking studies more exciting to look at than a finished considered painting, but one should not depend on this or even think about it really. Once one starts making sketches pretty I find they degenerate into clichés and shut out any real discovery.

Watercolour is the easiest medium for quick note-taking I find. Open pans are better than tubes, in a compact box with the normal folding flaps for mixing on. It is easy and quick to handle, needs the minimum of arrangement and carrying of equipment. If really rapid working is essential and drying time of each wash is a problem, either use the running of washes into each other, so that the whole thing is fluid and moving (which is not easy, and requires some experience); or use absorbent paper — heavy handmade watercolour paper or even blotting paper. The washes, if not too full bodied, will dry very quickly to allow other washes to be overlaid. Of course dabs of colour inside defined areas also gets over the problem neatly.

Colour of the sea varies not only with season and weather, but

also with the time of day. If it is possible, if you are enthusiastic enough, try visiting the seashore at dawn. Be prepared to go more than once until you catch the sun rising in a clear sky. Watch the colour changes at sunset too, and walk along the shore at night. The sea seems very different, much more awesome, at night — when colour is at a minimum.

Although direct painting at night is virtually impossible, a moonlit sea leaves a strong impression and may emerge in a painting later.

Many amateur painters like to produce paintings from picture postcards or their own holiday pictures. It is very easy to sneer at this practice, and it does bristle with traps for the unwary I think. The trouble is that the reality has already been processed; the colour film has frozen a certain interpretation of the visual aspects and left out all other sensations — temperature, wind, smell, etc. It is not a criticism of the photograph that it does this, it is almost impossible for it not to, but one needs to be able to react to these things to make one's own interpretation. If the subject of the photograph is a seascape that you know well and have drawn and made notes about on the spot, then I do not think it a bad thing to take information from it. But is is pointless to try to reproduce the photograph exactly — extract what you need to supplement your notes, then put it aside and draw on the memory of your feelings about the place. This applies especially to colour; photographic colour tends to be selective, in that a choice has to be made in exposure between rendering light areas satisfactorily or finding shadow colour and detail, and at the same time it is relatively literal and non-interpretive, without any emotional reactions.

Photographers will leap to defend the art form, pointing out that there is a vast amount of choice in the way of filtering, exposure control, printing, double exposure, etc., which allows entirely personal emotive statements. My point is that this is exactly what the painter has to do with the basic information, but with the particular capabilities of the medium and in his own way. The straight photograph is the basic information in each case — the interpretations will probably be very different.

Choosing any picture postcard which appeals and attempting to copy it on a larger scale I dont think a good idea, on the whole. I am hesitant to condemn any method of working, and am generally against any prohibitive system of things which are 'not done' or

thought to be cheating — the result is all important; how it was reached is irrelevant. Nevertheless I cannot see very much point in reproducing a photographer's work in paint, except perhaps as a technical exercise, and if that, why not use a great painting as a model instead, thereby learning something of a master's method.

Mention of the masters gives me an opportunity to introduce a reproduction of a marine painting by Georges Seurat, the famous French Pointillist (fig. 21). Pointillism was a method explored by a school of nineteenth-century French painters, in which paint was applied in spots or dabs of varied pure colour which, when viewed from a suitable distance, merged into mixtures of those colours. Thus an area which had mainly blue and yellow dots appeared green, pink and pale blue appeared pale violet and so on . . . the point was that the pigments were not actually mixed, the mixing was effected by the eye, resulting in greater brilliance and iridescence. They were after an impression of 'real' air and light and, indeed, were an extension of the Impressionist School.

Although you will have to look at a Pointillist painting yourself to see this colour phenomenon at work, this painting (fig. 21) has one or two interesting features even in black and white. Notice how light the sea is where the dark cliff face cuts it. The visual illusion it records is the apparent intensifying of tonal change at the *edge division* between contrasting tones, i.e. the dark appears to become darker and the light lighter just where the two meet. It is a very common effect and has something to do with the adaptation of the eye to different light levels I believe. The tonal steps in fig. 17 show it fairly clearly — each grey is absolutely flat and even in tone, but each appears to gradate left to right.

Seurat has seen that one side of the jutting rock is *light* against the darker sea and the other side is *dark* against light, and has made a feature of it. Compositionally the group of flying birds, the breaking of the horizon by the top of the rock, and the placing of the white sail near to this break, are all carefully contrived to give point and centre to what is basically a very simple composition and could have been very boring.

I wonder if he meant the cliff to look similar to the great wave of Hokusai (fig. 42).

The shape of the sea

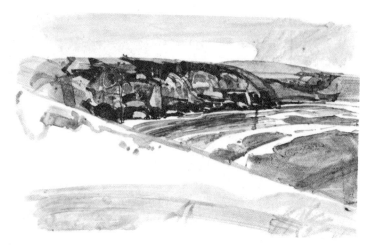

Fig. 22 Trebarwith sands

For the marine painter, composition can be something of a problem. The horizon is nearly always straight, or more accurately such a flattened arc as to appear straight. I say 'nearly always', because there are exceptions. A very low viewpoint may allow a breaking wave in the foreground to become the effective skyline, which can then have as much variety as a mountain range. Only the combination of a very low eye level and heavy seas would bring this about in reality, but there is no reason why one should not imagine it and create a swimmer's eye view from the trough of a wave. The woodcut by Hokusai in fig. 42 is an example of this type of composition, and of the fanciful symbolic imagery of the East, which, while being unreal in the literal sense, is very powerful and frightening and true in essence. I will talk further about this picture later on, but first of all I should like to consider composition generally.

From the most likely beach and cliff viewpoints, looking straight out to sea is going to produce a basic composition which can only be varied by moving the horizon line up or down in the picture. There will always be this pervasive horizontal division. Such compositions can hardly fail, but they are liable to become a little boring. They can be made more interesting by making the most of any pattern that can be found above or below the horizon.

37

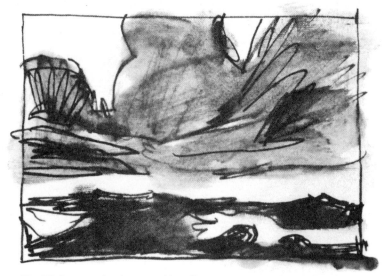

Fig. 23 Low eye level composition (from seascape by Emil Nolde)

For example, a low eye level composition would be fine to feature a dramatic cloud formation (fig. 23). Middle ground pattern below a sea horizon is used in the sketch in fig. 24. The breaking waves bunch the sea activity into an eye-holding nucleus, while the nearer shallow flowing water on the sand makes an irregular pattern sliding up from one corner and diversifying in its lightest tonal area. Near the middle of that bright area are two little figures walking along the beach, thereby providing a visual centre for the picture and incidentally giving scale to it. They do look remarkably small, but that is the size they looked to be; the waves must have been quite large. We often find this to be so; waves seen from the road approaching the bay always look like little ripples until we relate them to the tiny specks on the beach which are people. Struggling out on a surfboard those same waves seem like mountainous roaring monsters determined to hurls us back to the beach.

It is probably not a good idea to place the horizon line exactly halfway up the picture area, unless there is a very good reason for it. An intention to show the extreme symmetry of the view, or the great similarity of sea and sky, could be considered good reason, as long as it is really clear that it *was* really intended. Placing an incident-free horizon either above or below the centre tends to direct the view generally to the larger section, a movement which can be countered by strong contrast or incident in the smaller

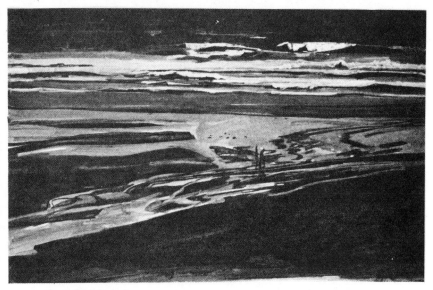

Fig. 24 Wet beach

part, thereby creating surprise or excitement.

In the painting in fig. 45 the horizon line has actually been reinforced by the line of the top of the rock. It is often stated as a law that such confluences must be avoided, but as with most prohibitions they can be made to work for you. In this case it seemed important *not* to break the calm horizontal, but to use it as a sort of clothes line from which to hang the rest of the composition. In other words, as before, one is using the lack of incident at the horizon to direct attention either above or below it.

All the action was occurring at the foot of the cliff, and in actuality the movement was reinforced by sound. The painter — without the assistance of sound or movement — must direct attention by compositional means. Placing the incident area at just the right point of tension between the larger more ponderous shapes is part of it, and leading the eye by convergent lines to the visual centre is another useful device.

Look at the diagrams on pp. 40–1. In each composition there is a small area to which the eye is inevitably led. These are the places where shapes impinge on one another, or where they are squeezed. Imagine that they are volumes of solid matter jostling for space or being acted on by a force — wherever pressure appears to be being applied or collision seems imminent here are points of attention. Compositional nucleii, you could call them.

Remember always that all these procedures are devices; they

Fig. 25

are part of technique, and technique alone is never any good. All that matters is that you have something to say — it's always possible for someone with the right conviction to break through technical difficulties. In fact many painters will say that technique gets in the way, and one is better without it. There have been many 'primitive' painters, so called because they are untrained, who have supported this contention by producing beautiful and very direct paintings while doing everything wrong according to accepted technical criteria. My feeling is that these painters are exceptional, and that there are countless other amateur painters getting into great difficulties with quite unnecessary and protracted technical struggles. One needs just enough technique not to have to think about it too much. But I could be wrong. The thing about the arts today is that almost anything you wish to do can be alright.

We have dealt so far with moving the horizon up and down or emphasizing it as a compositional aid. Another way is to turn so that land and sea share the horizon. The variations on this theme

Fig. 26

Fig. 27

Fig. 28

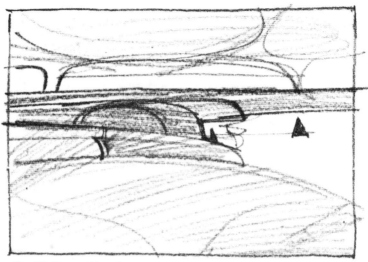

Fig. 29 Composition diagram

are endless, but the recurrent difficulty is that such compositions tend to be heavily weighted on the landward side and to run away out of picture on the seaward side. Attention has to be held inside the picture by some means.

The sketch on pp. 44–5 shows, I hope, one possible solution. I have tried to clarify the main compositional ideas in the diagram above, fig. 29, and fig. 30 is the original drawing done on the spot. It was January, very cold and windy, sunlight and heavy cloud with rain alternating, so that the sky and the lighting of land and sea was changing rapidly. It happened that I only had with me a ruled writing pad and a fibre-tipped pen. Marks made by these pens are easily smudged by moisture, so I made my drawing using pen, finger and spit!

Where rain was falling from the low cloud, it made greyish misty columns linking land and sky, framing bright slabs of sunlit cloud over the further hills. At this stage most of the far cliff forms were in shadow, but layered in tone, so that each succeeding promontory was sharply defined against the next by a subtle but distinct change of tone. Middle and foreground appeared by contrast to be much lighter, although in fact the tone was still quite dark compared with the bright areas of the sky, and the broken water at the distant shorelines. Incidentally, it is easy to be misled when assessing tonal values if you allow your view to become too concentrated. A close examination of an overall low tone area will reveal to the human eye (which is very good at

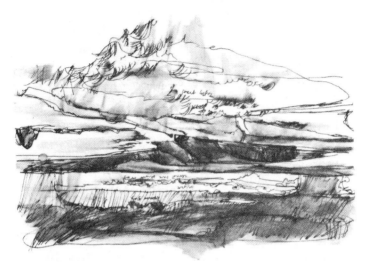

Fig. 30 Felt pen and wash sketch notes

adjusting to low light conditions) a great range of discernible tone. Before making too much of these changes however, you should compare them with the brightest areas to find their true value. The probability is that those changes which seemed extreme when you looked at them alone, will be quite subtle when related to the view as a whole.

In this case the darkest tones were in the middle ground and slightly to left of centre, making a strong contrast to the light area of broken water. Thus three big forms, two land and one sea, come together; and just at this junction there is a small black rock silhouetted against the foam: a very useful centring point. Also helping to stop interest sliding off to the right, is the rock outcrop jutting from the sea on the right; it works as a full stop, and the line of breakers from it links with the main area of breaking waves. Choosing to record the sky at that particular moment in time, when two columns of rain frame the picture area, helps centre attention too. All these elements exist in the natural scene, but the choices that can be made of viewing position, selection of picture area, lighting conditions, can make all the difference, and this is before exploring the possibilities of emphasis or even distortion.

A comparable compositional device was used in the picture in fig. 35. The only real incident here is the almost geometrically squarecut channel between the big cliff and the rock at its foot. Rock strata and beach pebble patterns were interesting, but not sufficient without this central point of tension.

43

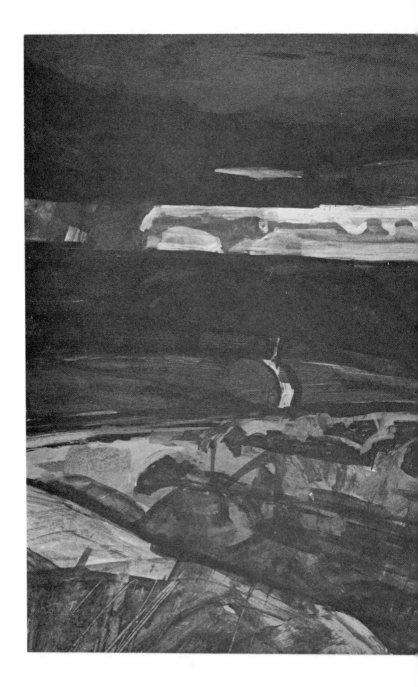

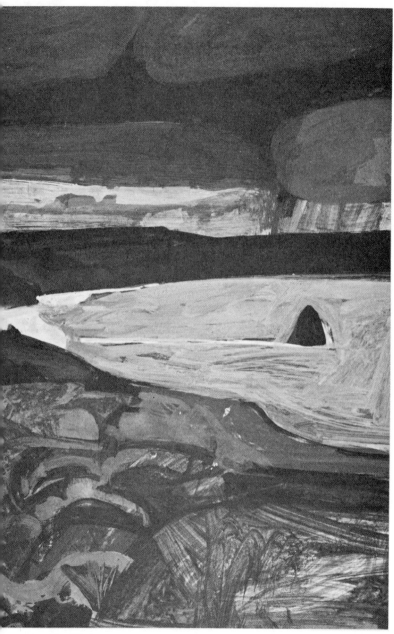

Fig. 31

Fig. 32 Large foreground object composition

Another way to deal with the pervasive flat horizon is to break it with a foreground object, a large rock or a boat perhaps. This usually requires a low eye level, probably necessitating a viewpoint down on the beach. While walking along a beach or quay, be open to the patterns made against the sea background by the objects that you pass. Unless a conscious effort is made to see these possibilities of pattern, the eye only sees *either* the near objects *or* the horizon, depending on focus, and rarely correlates the two. Try changing your eye level from standing to crouching or sitting, move to right and left and see how the foreground-background pattern changes. A group of boats on a far quay, which viewed direct may be a little dull, often takes on a new dimension when viewed through and past the rigging and super-structure of a nearer boat; or when framed by bollards, ropes, etc. Perhaps from one of the higher streets of a seaside town a little microcosm of harbour and boats — all colour and activity — can be glimpsed between two buildings, and the very narrowness and isolation of the view can somehow heighten its intensity.

Fig. 33 Stage 1

Fig. 34 Stage 2

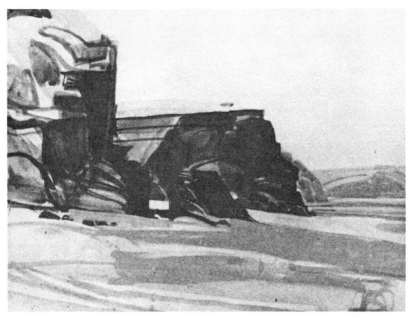

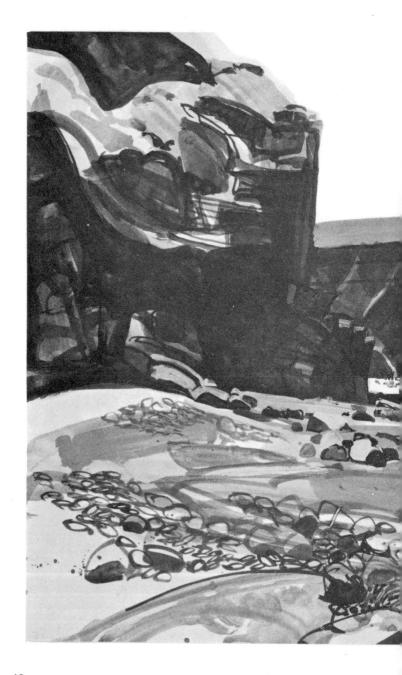

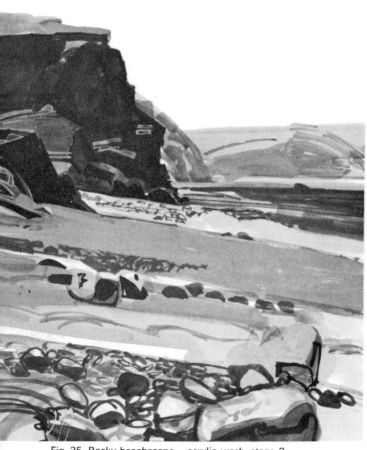

Fig. 35 Rocky beachscape — acrylic wash, stage 3

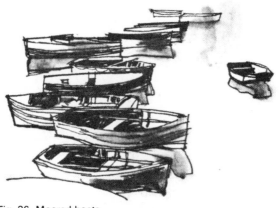

Fig. 36 Moored boats

Apart from compositional shape, the sea has a three-dimensional shape of its own. Its depth we cannot normally see, but its top surface is basically a horizontal plane. If a convincing illusion of recession and space is what one wants, rather than flat pattern for instance; then it is essential to try to make the plane of the sea lie at the right-angle relative to the land, and not to stand up like a wall. It is not easy; unlike a box, it has no parallel edges to which to apply perspective, but like a boarded floor it has a patterned surface (usually anyway, unless it is flat calm, which is even more difficult). Wave patterns are rendered progressively smaller and more compressed with distance from the eye. Careful observation and rendering of this gives a very strong sense of the plane of the sea. Shapes of white broken water which function as areas of pattern in perspective also help the illusion, again, as long as they are acutely observed. Jetties and breakwaters define an edge, and a succession of beaches getting smaller and flatter as they recede suggest a plane that an otherwise featureless sea is assumed to follow. Cloud shadows, which are more compressed nearer the horizon (as are the clouds themselves), changes of colour in the sea (usually intensifying as it recedes but not always so), the perspective of any floating object, raft, boat; can all contribute to telling how the horizontal plane lies. Boats are very useful, especially in the foreground, where other perspective clues are dimished. If the shape of the boat in itself and at the waterline is well drawn, the plane of the water is made apparent, and if this apparent surface is confirmed by a second object, further away for instance, it becomes really positively placed in a three-dimensional plane.

50

The mobile sea

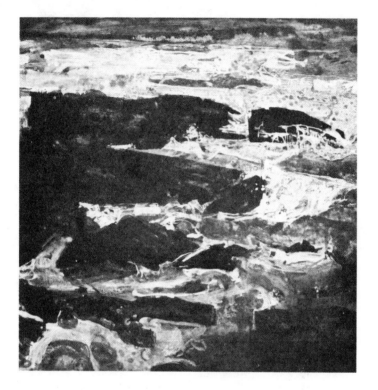

Fig. 37

When the painter looks away from the solidity of the land out to the vast stretches of water that cover most of the earth, he has to come to terms with a basic disparity between his art and the reality. The painting is static, the sea is on the move.

That statement, like most statements, is only partly true. The inferred difference in mobility between land and sea is really only a matter of time-scale, as the earth is on the move too. It never stops; the land masses shift and slide and grind against each other, rearing up in collision, interior material oozing out of the cracks to form subterranean mountain ranges – but it all happens slowly in a human time-scale. Although all the effects of the movement are there to see, nothing changes during the time that it takes to paint a picture. Neither is it true to say that the real bulk of the sea is very mobile. As far as we know the vast volumes of

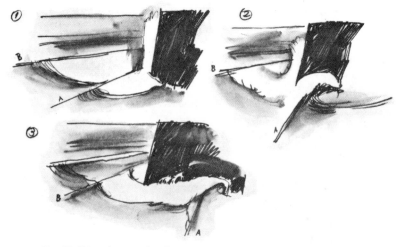

Fig. 38 Wave impact sketches

deep water don't move very much or very quickly. If they did, the marine horizon would not look as flat as it usually does. Where the sea is really on the move is in the upper layers and especially at the surface, and at the edges where it contacts the land. Even when conditions of flat calm pervade, there is some lapping on the beach or creeping of tide. When wind, currents, tides and shoreline combine to produce waves, and this is nearly all the time, events are occurring much faster than we can put them down on paper. It is no good sitting with pencil poised ready to capture the precise shape of a particular wave; it's all over and become something different before hardly a mark has been made. What can you do then? Sit and watch for a while. Discover which events are repeated, count the waves to see if there is a pattern to the incidence of extra large waves. Search out the wavelines and determine their direction in relation to the shore. Note what happens to the wave at its last stage of backwash from the shore, then look to see what is happening to the waveline immediately following it at this stage. On the next sequence check the next wave back again at the same stage. Note the observations either by writing or simple diagrams, or both. Next take a penultimate stage of the life of a wave, perhaps the actual impact with the shore. As before, check what the waves following are doing at this moment, especially noting impacts with rocks or promontories further out. In this way a complete picture of several sequences of events can be built up, so that a choice can be made later as to which sequence is best for any given composition.

A purely visual, less analytical way of note-taking is represented by the two sketches on p. 54. Here a point of impact between wave and rock was fixed, and observations made every time the event recurred, ignoring everything between. Gradually a composite portrait can be built up of a *series* of waves, each repeating the event in a similar way, so that the final wave represents the average appearance of a number of waves breaking at that point. It is comparable to an experiment in drawing we tried in an art school where I teach. Most of the students were in the centre of the studio, while two others bicycled around the outer edge. Every student looked directly outwards, and each time a cyclist passed a small visual fact was recorded. The passing cyclist was never quite the same, but as long as only truly seen and remembered facts were put down, an image was gradually created which represented the complete action of cycling, rather than a frozen moment.

The drawing in fig. 43 is not so much a drawing as a combination of visual and written notes put down as it happens on a piece of writing paper. Whenever confronted with anything which interests you visually, and which you think could make an interesting painting, make a note of it somehow on any scrap of paper, old envelope or whatever is available. It is essential to supplement your memory with something actually put down on paper. Even if the notes are lost, there is something about drawing a thing which impresses it on one's memory in a way that no amount of observation can match.

After making these first notes of principal shapes, I spent about half an hour watching the waves pounding against the near vertical cliff. No possibility of drawing the surf as it happens of course, so the only way is to look for the repeated patterns of shape. It was quite easy in this case to analyze the sequence of events. Well-defined waves seemed to be coming in groups of six or seven. The exact number doesn't matter to us, and the distance between the wave lines was roughly equivalent to the height of the cliff. (Judging dimensions relatively to each other is better than attempting to estimate actual lengths in feet or metres.) One or two waves in each group were detectable quite far out, and as they approached would begin to break at the crest, the wind catching and blowing the spray shorewards. As the first of these waves hit the cliff, it would be hurled straight up by the

Fig. 39

Fig. 40

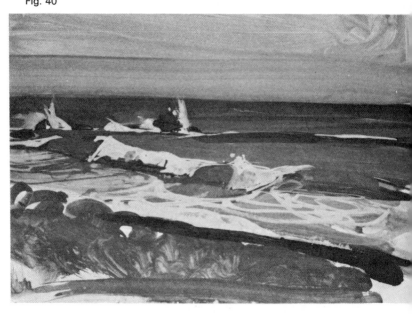

54

impact with the jutting corner, then, having been split, it would be deflected along the side of the cliff facing me in a sort of rolling progressive breaking like that around the bows of a moving ship. Immediately following this would be the backwash forming a concavity of white water, leaving hundreds of miniature mountain torrents streaming from the small rocks at the foot of the cliff.

As the following wave met the backwash, there would be a minor collision which only served to pile the oncoming wave higher still, so that when it hit the cliff the explosion of brilliant white water would tower up nearly to the top of the cliff. It was astonishing how slowly and with what impression of great weight this tower was erected, slowed, paused and then fell back into the sea, almost like a slow-motion film. The area of the sea surface which was white maintained a remarkably regular shape, and could therefore be quite precisely delineated. I also drew a series of diagrams to show stages in the cycle of wave collisions as described above. Fig. 38 (1) shows a wave of waveline A impacting the sharp edge of the cliff, the next waveline B following up with a fairly flat shallow trough between. The next diagram (2) shows the waveline A continuing to advance, breaking across the cliff in a deflection, while the head-on collision water is already falling back and beginning to backwash. In the third wave A has progressed further and is now swelling up over lower rocks and curling over on itself as the beach shelves, while the backwash from the cliff is now strong and in collision with the advancing waveline B. The cycle then begins again with wave B hitting the cliff in its turn.

It would be nice if we could somehow show all these stages in one painting, and indeed there is no reason why not. Overlaying the progressive patterns to get a sense of movement can be experimented with, but if that seems unacceptably unrealistic, a moment in time can be picked, and the motion to that position suggested by the rhythm of the line and pattern of shape on shape.

That may sound complicated but it isn't really: it's just a matter of feeling the way that the waves are moving and letting your brush move with the same rhythm.

Anyway, if we treat as stage one all the drawings done on the spot, including the stage analysis sketches of the waves, then the compositional construction (in fig. 44) is stage two. Here the disposition of the main masses has been sorted out, so as to

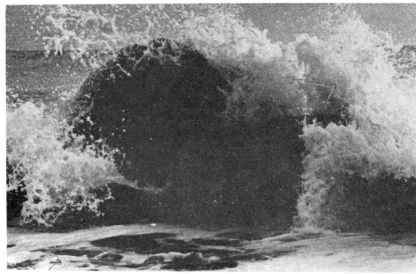
Fig. 41 Breaking wave. 1/1000th second exposure

establish the positions of tension points as centres of attention. As I said earlier, the coincidence of horizon and the top of the rock was intentional, so as to concentrate attention below the horizon onto the waves.

After that, the problem was to sort out tones and shapes in such a way as to suggest the solidity of the rock and the constant movement of the sea's assault. The treatment in the later stages is a matter for individual choice, but it is likely to be more manage-able if the thickest paint is saved until the last. Shadow areas work best in transparent, comparatively thin paint, and if such areas get out of control and clogged up with a build-up of opaque thick paint, it may be necessary to scrape down to the surface and try again. Light areas, on the other hand, may benefit from heavily built-up layers of paint (called impasto), as the rough edges catch the light, adding to the brightness of the area and increasing the effect of solidity.

I took some photographs as well, but they were not much referred to. They were taken as a safeguard — a source of extra factual information in case of need. Beware of using one single photograph of breaking waves as reference, for it records a split-second event and gives no clue about the moments before or after. Without some knowledge of the mobile pattern, it is very difficult to select and simplify, and consequently difficult to make a personal statement. To speak about 'statements' in painting

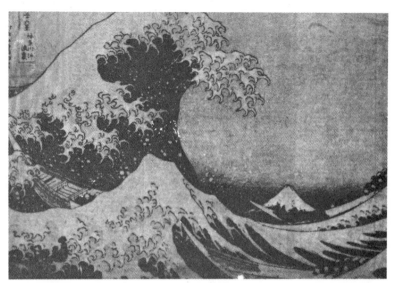

Fig. 42 *Hollow of the deep sea wave* by Hokusai

seems strange and inappropriate to many people. I think it means, in objective painting at least, that by selecting some particular aspect of light or shape or form, you say to an observer not only that 'I was at this place' but also that 'I discovered *this* about this place which pleased/terrified/amused/me'. In other words 'This is how I felt about this thing that I saw, do you recognize the feeling? I am quite sure this is not a complete explanation of the aesthetic experience, but at one level I think some such striking of a chord which means experience shared, or vicarious experience which one believes in because other parts ring true, is the basis of most people's response to a painting.

Returning to the use of photographs, although one moment frozen on film is dangerously uninformative for the painter, a series of photographs could permit analysis in the way described earlier at the actual location. Not quite so good of course, but better than nothing.

I suppose that one of the most popular types of sea painting with the buying public is that showing a wave rolling in towards the viewer, thinning near its crest so that sunlight glints through the pale green, and further along the wave it curls and breaks in bundles of white foam. Now it is true that this is how waves *do* sometimes appear, but if you know the paintings I refer to, perhaps you will understand what I mean when I say that there is something very superficial about them. It is a show of dexterity;

Fig. 43 Tintagel, sketch notes

like saying 'Look I can paint this wave to look transparent', and is in the same category as 'Look I can paint this eye so that it looks watery and real'. In both cases the superficial trick is very easy, the more *difficult* thing that all good painters go for is making a complete painting, only using such things as glinting sunlight through a wave and highlights in the eye if they are really appropriate to the painting, and not just an eye-catching trick.

The point of this is not to condemn these painters – they could be right, and everyone decides for themselves how they paint – but to suggest they are not good models for the amateur artist. Apart from the question of whether or not commercially-popular sea paintings are worthwhile, I am quite sure that to copy them would be disastrous. The sea itself must be the source, and if other painters' work is copied it should only be as an exercise to discover how *they* solved the problem. In this case, keep to the masters. Go to a national collection of paintings for guidance and influence, not to the picture department of the local store.

Having said before that there are no rules, I will now summarize a few things, especially related to the sea on the move, which I think are rather dangerous and probably better avoided at least at first: Avoid painting violently breaking waves entirely from a photograph. The action will be frozen and the painting will have no 'feel' of the dynamics of the incident.

Fig. 44 Stage 2

Do not pile thick white paint indiscriminately on a seascape in order to make the sea look rough. Observation of the form of waves in a rough sea, and the characteristic shape of foam areas, is much more likely to be effective.

Try not to acquire pet methods for depicting moving water which are based on preconceptions. Try instead to come to the sea with an open mind, ready to discover something entirely new every time.

Do not depend on other artists' observations, whoever they may be. Especially do not copy the sort of paintings which show wave 'white horses' changing into real white horses and galloping out of the sea!

I would like in this context to talk about one or two of what I consider to be great sea paintings. The Hokusai woodcut in fig. 42 is one of a series of thirty-six views of Fujiyama produced during the period 1823–29, before photography I would point out. On the opposite page is my photograph of a breaking-wave, exposed at 1/1000 second and revealing remarkably similar shapes of flying foam.

I suspect that there is no valid inference to be drawn, but I like to think that it shows how right a great artist can be, using a combination of observation and creativity. He has looked at the sea, and knows all about how water moves, you can tell that; but

Fig. 45 Stage 3. Rough sea at Tintagel

Fig. 46

he has not produced a 'realistic' picture. It is more 'super-real' —
his idea of the vitality and force of the sea. The men and their
wave-shaped boats are not immediately noticed: they are over-
powered by the great wave in form, and perhaps in a moment to
be overwhelmed in fact. But besides this the whole thing is very
beautiful to look at, the composition artfully contrived so that
distant Fuji still somehow commands the whole scene. The
mountain stands quite aloof from the marine drama, strangely
similar to the waves in shape, but not to be mistaken for a moment
for anything but a static land shape. A very different attitude is
exemplified by the Turner in fig. 20. Here atmosphere, not form, is
the primary interest. Turner at this stage was pursuing the sub-
stance and texture of air itself, stressing its presence all around
us, and the necessity to look through it at the world. Water vapour,
smoke, spray, steam, and in this case snow, interested him, and
the interplay of light diffused through the atmosphere or reflected
in water. There are others of his paintings which exemplify this
more clearly than this one, and which I would have preferred to
show, but they are mostly so dependent on infinitely subtle misty
gradations of colour that they do not reproduce well in black and
white. Tonal contrast in this picture is stronger than most of this
period, so that even in black and white the colour can be sensed,
the wetness of the water felt. Having the most brilliant light for
juxtaposition with the darkest dark in the centre of vision is a
familiar Turner idea, and you may have noticed other compositio-
nal aids in the form of wave lines and clouds which point the
centre of interest. I *think* it is a paddle steamer struggling along in
the heavy seas, its mast silhouetted against the light, but I'm not
entirely sure, and I don't think it matters too much.

The shore

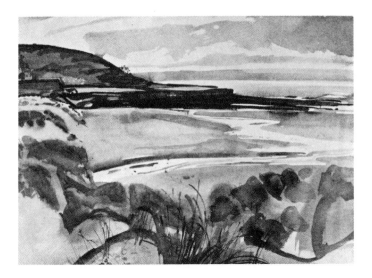

Fig. 47 Wash drawing of sand dunes

Although the sea itself is rarely still, and for this reason a little difficult to observe and draw, the effects of its movements are clear to see in the shaping of beaches and cliffs. A marvellously complete and explicit record of the continuous activity of the sea is written there, in the shore, for all who understand the language. I know very little of this language, and I would not expect everyone who aspired to paint sea and shore first to study geology. Much is obvious though, even to an untutored eye. Some of the most remarkable sea-eroded rocks I have seen are on the Atlantic coasts of the Isles of Scilly, although there are, no doubt, many others like them on unprotected oceanic coasts throughout the world. Thousands or even millions of years of pounding seas have worn these coasts into a fantastic array of strange shapes. It is hard rock, granite in the main, and it hasn't fallen easily. It has withstood the barrage long enough to have been shaped infinitesimally slowly into magnificently varied monumental forms. When I first saw these rocks it was summer, but they were under the sort of attack which is normal during the winter — enormous, crashing waves, gale force winds, a constant thunderous noise. It was impossible to draw there, but very exciting to watch. A couple of days afterwards the weather reverted to summer calm, the sea was blue and clear. It was difficult to believe that the benign and balmy

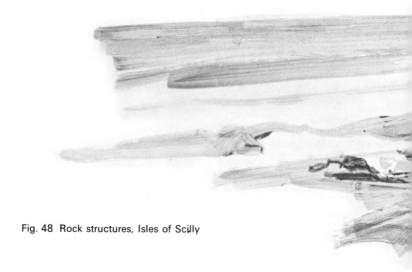

Fig. 48 Rock structures, Isles of Scilly

water could ever have been any different. Except for the rocks: there they were, battered and twisted, and you knew that you hadn't imagined all that ferocity. However mild the sea looked now, the rocks proclaimed loud and clear that this coast was a wild one, an Atlantic coast, not to be trifled with.

Some of the rocks shaped by the sea take forms which are rounded and smooth in line, like great pieces of sculpture (which is what they are, I suppose, only without human intervention). These shapes are not random, they are the result of continuously repeated scourings, which, at a rate so slow as to be difficult for us even to contemplate, have transformed hard, angular rock into sea forms, with all the sweeps and curves, crusts and troughs of waves themselves. I find them very beautiful and satisfying to look at. I also think that when you draw them you must give them the same acute attention, the same critical eye for proportion and balance, as when you are drawing the human figure.

You may find other rocks which resemble fantastic architecture — the picture on this page (fig. 48) shows a small headland that looks just like a mosque, with turrets and central dome. These types of rock, I assume from the number of criss-crossing fissures, are more inclined to become undermined, to fracture and collapse, so that they don't stand sufficiently long to become hollowed and rounded, only long enough for the sharpness of corners and edges

to be softened. Again they should be lovingly observed, and not treated as a heap of haphazardly shaped lumps. Of course no one is going to be able to say 'That doesn't look like that rock', as they can say of a drawing of a horse or a figure that it looks wrong, but if for this reason you allow your vision to become sloppy and superficial, it will show in the drawing. It will have less authority, less credibility.

Once having extracted the vital shapes and volume of a particular piece of shoreline, there is nothing to stop you treating it in a rather imaginative way, and creating something from these ingredients which is a long way from straightforward realism.

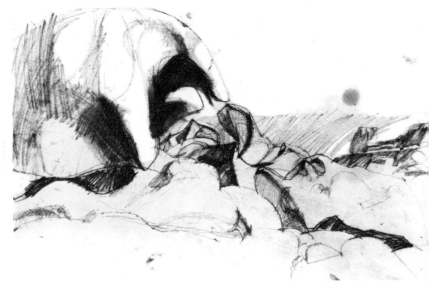

Fig. 49 Rock, Isles of Scilly

I did the drawing in fig. 49 sitting in front of those rocks, and I believe it is a fairly accurate statement of the rhythms and forms that were there. Looking at it later, two years later in fact, I thought it had a slightly eerie, moonlit look to it. A drop of coffee or something, which may or may not be visible in the reproduction, had fallen on the drawing, just above the horizon, and looked like a heavenly orb, which may have added to the impression. I thought it might be interesting to develop the drawing into a more imaginative design, but using the forms I had discovered from the actuality.

The second stage was a colour rough (fig. 50), in which I tried to decide how best to use solid tones to express what was previously linear. I am not too keen personally on popping the sun or the moon haphazardly into pictures as a compositional prop. It has been done so much that it has become something of a cliché, but there are occasions when it seems appropriate, and this seemed to be one of those occasions. Sun or moon always give an added dimension, an extra air of mystery, perhaps because they point to the existence of unknown worlds outside our own, but it is an easy trick and it will lose its power if used too often.

I felt that the third stage should not be a painting as such, but something which would allow several combinations of colour and tone to be tried and compared for maximum effect, which meant

Fig. 50 Colour rough

using one of the many print methods. Probably the simplest method to apply paint, other than by brushing it on, is to spread the paint on glass or some other flat surface and press it to the painting surface, either through a cut mask or without. Colour so applied has a distinct quality of its own which, although it can vary greatly (depending on how the paint is applied to the glass, the pressure when transferring, the type and thickness of paint, etc.), never looks the same as paint directly brushed on. It is a print method and is usually called monoprinting. I started the third stage (fig. 54) of this little picture of the rocks by applying broad areas of colour in this way.

It is usually only possible to obtain two or three prints at the most from any one application of paint to the glass, and each print made is much paler than the previous one. To ensure exact registration of successive printings on any one version, it is a good idea to tape the paper in position by one edge.

While paint is applied to the glass, the paper can be flapped back out of the way, but because it is permanently attached, it will always be pressed onto the glass in exactly the same position. Up to four pictures could progress at the same time in this way, one folding each from top and bottom, and one from each side. Of course registration can be achieved by marking the position of the corners of the sheets of paper, which marks can then be used to reposition it and any number of other sheets of the same size.

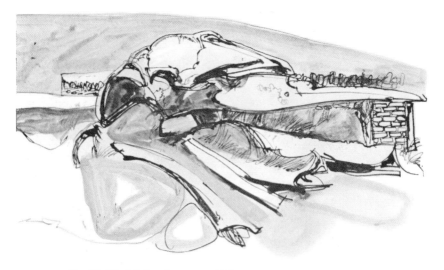

Fig. 51 Whale's head — pen and ink

Most types of paint will transfer in this way, but printing inks — which are oil-bound and rather tacky — are usually best, especially if applied by roller and printed with some pressure. Acrylics are usable, but the quick drying makes printing a matter of speed and timing.

In general, a lot more paint is used when monoprinting than in painting direct, so be prepared for an expensive time, with bulk quantities.

The watercolour painting (fig. 55) represents an entirely different kind of shoreline. Actually the sketch in fig. 47 shows more clearly how the area looks in general. It is a sandy bay with a very shallow sloping beach, straddled by areas of low dark-coloured rock. They are the same rocks in each, viewed from much closer in the colour picture. This beach is backed by dunes, which are constantly being blown further inland by the prevailing wind, and which support tufty growths of a dry reed-like grass. It is one of those beaches where the tide always seems to be out, I suppose because it goes out so far that only when it is fully flooding does it seem within reach at all.

It is a wide open and often windswept place, the sea rolls in and dissipates its sometimes considerable energies on the flat sand. There is no thunderous battle between wave and cliff; it is the wind that has most to do with the changing shoreline here. In fact it was this watercolour that I referred to in the materials chapter, talking about the difficulties of painting in a high wind.

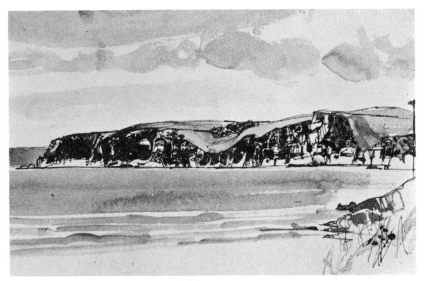

Fig. 52 Bigbury cliff – pen and ink

Fig. 53 Next day – watercolour

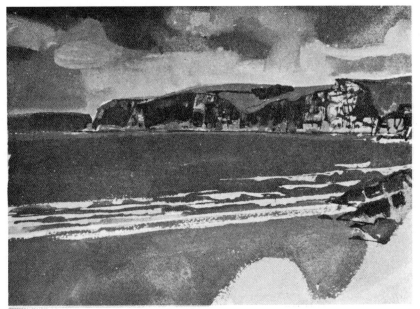

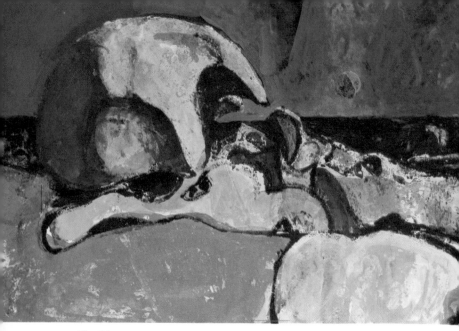

Fig. 54

Fig. 55

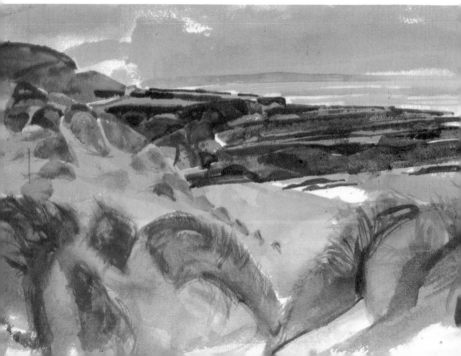

The wind here was unbelievable — not hurricane force perhaps, but enough to make me feel (as it sometimes seems in particularly nasty conditions), that the elements are somehow directed against oneself, personally and malevolently. Almost the worst part was the bombardment of needle-like particles of sand, which drove into every crevice, into the paint, water and brushes — but I stuck it out, I say smugly, and perhaps the situation made me work more urgently. Certainly it did not take long, the washes dried almost as soon as they were laid, and although I must say it doesn't look very windy, the dune grass clumps took on wind-blown shapes which I think are rather nice. Designers' gouache, watercolours, on heavy rough-surface handmade paper (unstretched) were used for this watercolour, incidentally.

Such conditions are not all that unusual by the sea, and it is quite impossible to work unless everything is firmly anchored in place and the artist himself is well protected. Using an easel is out of the question, and lots of tape or bulldog (spring) clips are necessary to hold paper to board. One hand can then hold the board as steady as possible, water pot wedged in sand or cleft of rock, and paintbox heavy enough to stand on its own, preferably with a firm prop for the open lid. The palette is a problem, but in bad conditions I usually resort to a spare piece of card extended outwards to right or left of the board on which I am working. This is then firmly held by the 'board-holding' hand.

One is tempted to wonder whether all this trouble is worth taking. I think that it is. If one only works in clement weather, the real character of the sea will be misrepresented, and there will be many less opportunities to work and to make new discoveries. In fact I feel that bright sunlight sometimes *obscures* the vital character of a place. There have been times when I have sat down to paint a rocky shoreline which, under a cloudy sky, was all strong sculptured forms, telling of great earth pressures and subsequent bombardment by tons of water, only to find when the sun came out and shone prettily on it all, that it suddenly looked benign and characterless. Surface forms becomes more obviously apparent of course, but the underlying general structure is obscured. This does not always apply — quite as often strong light *reveals* underlying big forms, but my point is that for the best picture, a blue sky and bright sunlight are not obligatory. There is a sort of cliché linking the seaside with summer sun which, I

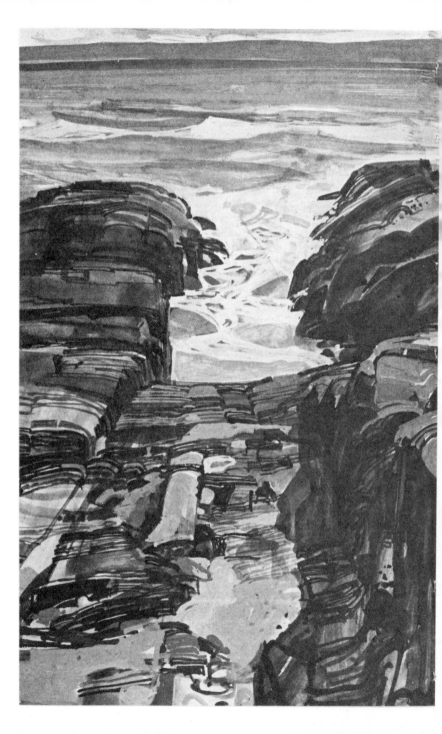

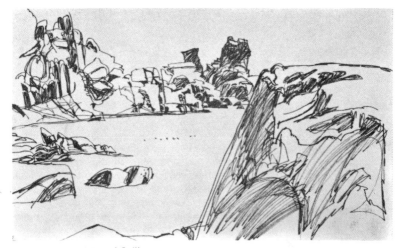

Fig. 57 Rocks, Isles of Scilly

Fig. 56 *opposite* Slipway, Croyde, North Devon

must admit, tempts me to concentrate on the severer aspects of the sea.

Occasionally I have included in this book subjects which are not strictly seascapes, but I believe this to be justified by such subjects being directly connected with, shaped by, or strongly reminiscent of the sea.

While walking on a cliff top looking for interesting rock forms this summer, I saw, perched on the hillside inland of the cliff, a group of what seemed to be most interesting sea-formed rocks; or was it a sculpture or driftwood? Moving closer it became obvious that it was the skull of some species of whale, parts of which had come adrift and lay where they had fallen. Someone had mounted it on a rock and propped the end of the long jaw on a small pillar of brick, so that it pointed out to sea.

It had a striking monumental quality, and incredible similarity in the character of its form to the gale-eroded rocks of the Scilly Isles (fig. 49).

It would probably be fanciful to endow this similarity with great significance, but I think one should be alive to such things — fanciful or not — and always receptive to visual stimuli from any source, even though the primary objective may be only to paint the sea itself.

This particular subject may also serve to illustrate what I have said about mere accurate copying not really being enough. My first quick painting done on the spot seemed to have no bulk and

73

to have missed completely the monumental look, so I tried to analyze the main movements in a simpler way in a pen and wash drawing (fig. 51). This is still missed the point, and a return was made to the spot to try to sort out the underlying strength of the forms. I found I had to increase contrasts, simplify surface detail, and unify and darken the background, in fact, completely repaint with more assertion and less slavish copying of the surface reality. The final drawing (fig. 69), while still falling far short of the presence of the actual object, is nearer to it.

Reproduced on p. 69 are two drawings of the same subject drawn from exactly the same viewpoint, but made on successive days. On the first day the sea was calm and the sky uniformly overcast, although the light was quite bright. The pattern of growth and fissures on the cliff face made a sort of frieze separating a flat sea and a flat sky. Next day the weather had worsened, skies were dark and lowering, and the wind was almost gale force.

Fig. 58 Chesil bank, Dorset

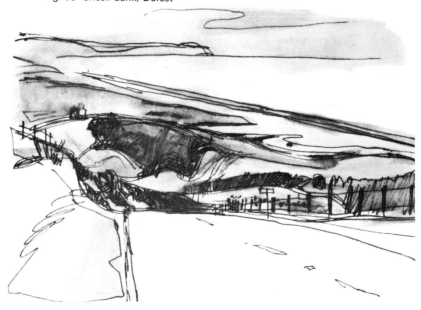

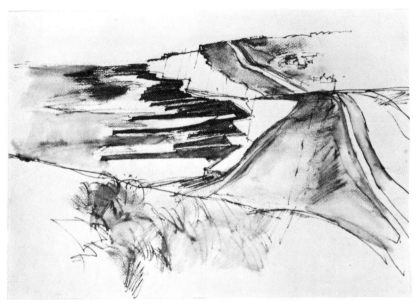

Fig. 59 Chalk cliffs, Saltdean

To paint outside in such conditions was impossible, but fortunately I was able to position my car (dangerously near the edge) so that the cliff could be seen through the windscreen, and the painting was done from the front passenger seat. When painting out-of-doors, it is always debatable whether personal comfort or exactly the right viewpoint, however uncomfortable, should take precedence. My feeling is that, in general, one should be well enough equipped to be able to make oneself comfortable in the *right* position, but that if this is really impossible it is silly to stick it out with freezing hands, running eyes and the increasingly urgent necessity of taking shelter — and expect to produce anything any good. Wind, spray and light rain can be braved, but cold is something else. Rather than get really cold, better make a few notes to be amplified in the studio from memory, or else retire to a more sheltered spot, even a car, and draw whatever can be seen from there.

There is a road not far from where I live in the south west of England which, at a certain high point, presents a sudden wide view of the coast which always comes rather as a surprise. I have driven along the road many times, and yet I am always caught a little unprepared; and although I want to stop and look for a few

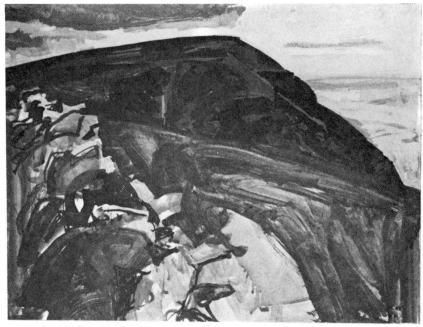

Fig. 60 Headland, North Devon

moments, there always seems to be a car following close behind, and by the time I have been able to slow down and stop, the high vantage point has passed and I tend to think that it will probably be even nicer as the road nears the coast. It isn't; there is just not another comparable view of this unusual coastline.

The point of this little story is that one should grasp the opportunities that present themselves. So often one goes on and on looking for a viewpoint that is just a little better, only to end up with no drawing at all. If you pass a view that seems in retrospect to be promising, go back and have another look.

I still haven't made a painting of my surprise vista, but I did at least manage to stop at the top of the hill and make a small pen sketch (fig. 58). What I tried to analyze was the special quality that this vista had that hit me each time. On reflection it seemed that it was partly a matter of changes of level and plane. The curving downhill stretch of road was important to it, and so was the curvy wooded hill in the middle ground. Then the flat plain, with its straight beach and shingle bank running dead parallel seemed to tilt up towards me, the horizon (on this day at least) being only a misty blur. Each time I see it, it looks different, and I

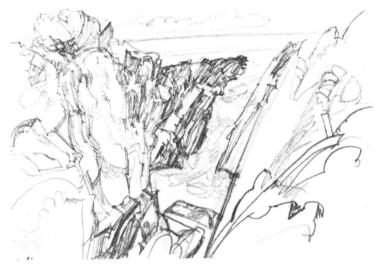
Fig. 61 Rocks — pencil drawing

expect a few more drawings will be made at different times of the day and seasons of the year, before I really get it sorted out.

Rock strata on the beach are usually concealed by shingle or sand — but not always. There are sea coasts where the strata visible at the cliff face can be followed down into the surface of the beach itself. Such a foreshore is the subject of the drawing in fig. 62. Looking down from the cliff top, there is a continuous succession of beautiful patterns over several miles of beach. With such explicit patterns as these it is difficult to draw generalized forms. There is no real way but to sort out the rhythms and draw the shapes in quite a detailed and accurate way.

In this case the main shapes were first put down in watered-down sepia ink and brush, the detailed pattern being built up with darker glazes of sepia ink and opaque whites and greys. At the time the light was very flat, so that the elements of the pattern owed little or nothing to cast shadows. The area of light and shade related instead to the interplay of strata lines, and the standing water contained within them. As the striations are traced further into the picture onto the far beaches, they are seen to define the undulating form of the foreshore, and their decreasing scale gives a sense of distance.

Long views of the coast and beaches, although fascinating, are not the only rewarding aspects of shoreline. There is a world of closer, more intimate, beachscapes, made up of rock pools, driftwood, flotsam and jetsam of all kinds.

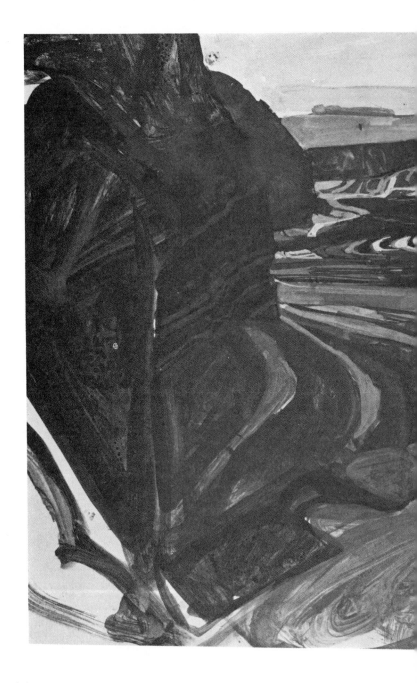

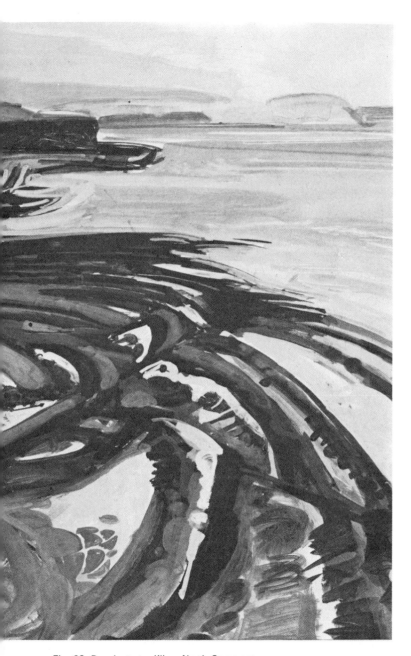

Fig. 62 Beach strata, Kilve, North Somerset

Fig. 63 Driftwood, rocks and seaweed

There are beautiful compositions to be found even in such unlikely things as the floating scum and debris that collects in harbours sometimes, or in the tangles of rope and rusty equipment. To change gear visually, and focus on the microcosm of pebbles and shells, can open up a whole new set of possibilities. Sometimes it is possible to forget one's size and imagine that the miniature seascape of the rock pool is the norm, so closely does it resemble full-size topography. There is something very peaceful and satisfying about gently wandering along the tide line, searching for interesting objects — picking up rock after interesting rock, pieces of cork float, coloured glass and pottery abraded into pebble shapes, wood shapes looking as though they have been carefully sculpted and smoothed, until the load becomes ridiculously heavy and all but the very nicest pieces are regretfully dropped. When your treasures are laid out at home, they recreate the beach; they are so obviously of the sea, so different from inland objects. Why not set them up as a still life, and if your painting of these sea-shaped things begins to resemble a fanciful marine-scape, that's fine. This is one of the delights of painting: images can be mixed in time and place, it really isn't obligatory to place everything in a picture strictly in the context in which it was seen in one moment. You should feel free to arrange elements as you feel they are important, or just as you would like them to be. There are *no* rules that must be obeyed in painting.

Flora and fauna

Fig. 64

While searching the foreshore for interesting objects, inevitably life-forms themselves will be found. There are very few beaches without some shells, and the diversity of size, shape and colour is very great, and they are all beautiful.

In the drawing above the little striped shells are types of periwinkle, some of which are minute and brightly coloured, mostly yellow, orange and red. The spiral object at top left is a fossil of an ammonite. They are quite common in certain coastal rocks of Dorset, and lived in the seas around 170 million years ago!

Crabs are all too often represented as vaguely circular pink bodies bristling with rubbery legs, two of which end in nasty little pincers. The same applies to lobsters, crayfish and many other common sea creatures. It seems we only look at these animals in the context of their threat to us: they pinch us, therefore they are walking pincers.

In fact they are really rather beautiful too. Those fearsome pincers, although they *can* do damage, are also used as delicate eating utensils. The jointing of the main claws of crabs and lobsters

Fig. 65 Lobster

is a marvellous solution to the problem of movement when the skeleton is on the outside. Looking closely and carefully at these creatures (who, incidentally, have been around a lot longer than man) shows them to be very delicately and neatly organized, well adapted to life in the sea, and very rewarding to draw.

Fig. 66 Crab claw

Rock pools are probably the easiest available source of varied sea life material. The water is usually clear, and not too deep, sea anemones open up, and variegated seaweeds look healthy and colourful – unlike the rather dank heaps that are left high and dry by the retreating tide.

There is of course a whole vast other world below the sea's surface, the measure of which we are only just beginning to realize. Anyone who has explored this underwater world with the aid of Scuba equipment, as I have, knows the absolute 'otherness' of this element, once the surface has become the ceiling, shutting out the world of air, wind, sound, smell and above all gravity. Sub-aquatic views have as much variety of topography and flora as land ones, as long as the sun can penetrate, but as the sea floor descends to depths where sunlight cannot reach, it appears more and more barren. We know that the water itself teems with life, but since it is mostly microscopic, and plant life is entirely absent, it doesn't look very hospitable.

In relatively shallow water, where the light is bright, the diver gradually becomes less fearful of the strange element, and can eventually feel quite at home moving weightless in this fascinating world. Perhaps such scenes, although beautiful, are not yet familiar to enough people for paintings of the underwater to have any universal meaning; and painting on the spot presents problems!

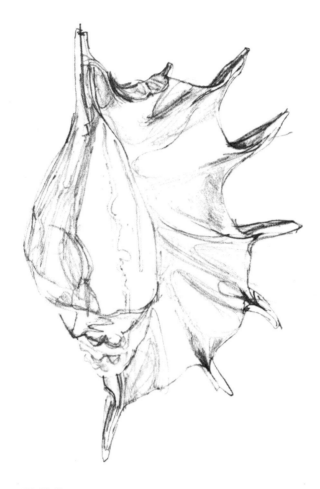

Fig. 67 Shell

I think though that there is something to be said for seeing the other nine-tenths of the iceberg — the broad calm base of rocks which, at their surface-breaking tips, are all flurry and foaming water; the quiet valleys floored with bright sand and ringed with gently waving forests; where you can lie still and not know that at the surface the breakers are piling up and rushing at the shore.

Most of us, most of the time, relate the sea with the shore. We observe the sea from the land, and are fascinated by the line where the two great elements of land and sea contact each other. For this reason, I think, it is the flora and fauna between the tide lines which strongly evoke the atmosphere of the sea. Fish which can never emerge from the sea and live, seem, as they lie lifeless on the fishmonger's slab, to have a different meaning.

They are lovely things mostly, but so much more attractive in the sea and alive; on land they somehow just become so much food. This is a purely personal and perhaps isolated view – I am sure that many people will feel quite differently, but a still life of fish just doesn't have the same strong evocation of my times by the sea, as for example, a crab's claw, a shell or a piece of driftwood has.

One thing to remember if you *do* decide to paint a fishy still life; pay particular attention to the actual colour, especially of the bright scales. Because fish are rather shiny, the temptation is to cover them with highlights. Resist it: observe the bright areas dispassionately – although subjectively it all looks shimmery, it is probable that most of the area is really quite a positive tone and colour, the truly white highlights being limited to a small area.

It must be realized that one's feelings about the sea and its life depend very greatly on one's own experience in relation to the sea. An Eskimo carves seals from the bones of the animals themselves, but although I know that seals live in and by the sea, and I also know or can find out what they look like, they do not form part of my sea-experience and so have no strong evocations.

I like the Eskimo's carvings very much, because for him they represent experience, in fact at one time the seal represented the difference between life and death for the Eskimo: no wonder the sculptures have the look of sacred objects.

Each person must try to discover for himself what seems to be most significant, and then get it over as strongly and simply as possible.

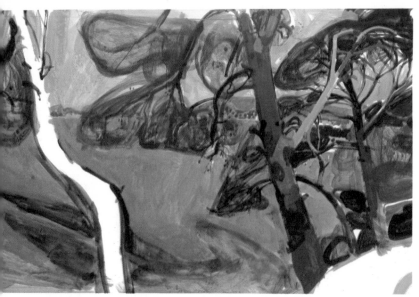

Fig. 68

Fig. 69

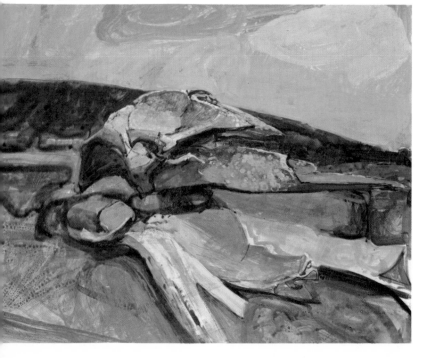

Man and the sea

Fig. 70 End of pier

If one spends much time by the sea and shore it becomes imposs-
ible to ignore the thousands of objects made by man to enable him
to conquer or come to terms with the sea — things like boats and
anchors, mooring lines and buoys, nets, floats, lobster pots,
fishing tackle of all kinds.

 They all evoke the sea and are part of the pattern of shoreline
life, which so differs from inland. Because they are functional and
from long experience have been refined so that they work more
and more efficiently, these objects can be said to be sea-formed.
Certainly they rarely strike a discordant note with the rocks and
flora and fauna of the seaside, and sometimes the similarity to
these natural forms is remarkable. For this reason they repay care-
ful and close study, not so much of their details, although these
can sometimes be fascinating, but of their basic forms.

 Boats especially, which must float, be stable and slip through
the water with as little resistance as possible, are very subtle and
rewarding in shape.

 They are only difficult to draw if you come to them with pre-

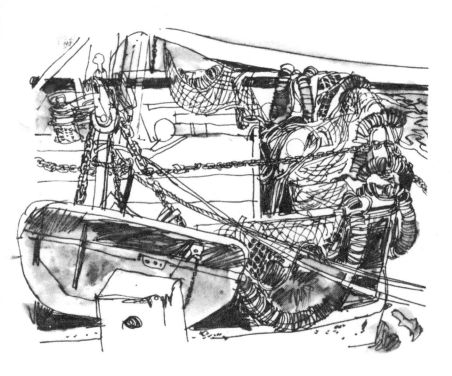

Fig. 71 Nets on stern of trawler

conceptions about their shape. Draw what you truly see, and don't try to fit in what you see to your idea of what a boat *should* look like. If, for instance, a boat is viewed from a high, three-quarter front viewpoint, the curves of each gunwale will be very different; so do not draw them the same because you know that in plan the boat must be symmetrical. Similarly there may be rather unbelievably little of the far side of the bows visible in view of the width of the boat. Believe it. If you see it, believe it.

Try not only to see the intrinsic form of each boat, but the composite form and pattern of a cluster of them. To be conscious of the shapes *between* groups of objects is a help to seeing the pattern of shape. After all these 'shapes left' are just as important a part of your two-dimensional painting as the parts which represent the objects.

There are also the permanent structures that human beings erect when they settle by the sea. Such things as piers, landing platforms, quays, sea walls, boat houses, breakwaters and harbours, and in the larger towns the seaside promenade (boardwalk),

coloured lights, fish shops, amusement parks and bandstands. I personally prefer the objects which have been used traditionally to wrest a livelihood from the sea, rather than the shoreline exploitation of man's amusement needs. But I realise that this is a selfish attitude — after all, if *I* like to visit a beautiful place, why shouldn't everyone else, even if its beauty may be changed or even destroyed thereby. In a curious way even in the most outrageously holiday-orientated seaside towns, it is possible for an artist to find attraction and interest; and even if horror and repugnance is all one can feel, it is still valid to state this in your painting.

There should always be a point of view: you will feel awe, love, wonder, perhaps only curiosity, and perhaps, as I said, revulsion or bewilderment. Whatever it is, allow it to come through in your painting, don't let too much slavish description mask your feeling about the place. Only in the instance of complete non-reaction and boredom is it fairly certain to be unprofitable to paint.

Ropes, cables, nets and all the other paraphanalia of boating and fishing are almost always rich sources of pattern. In many parts of the world, boats have traditionally been painted in bright colours, and they always seem to be just the right colours for the place and the climate — fishermen must have an innate colour sense. Even in the more seriously minded northern fishery ports, where the basically brown or black boats are only enlivened by white painted numerals or the occasional straker line, their gear by contrast has taken on a much gayer appearance in recent years. Self-coloured plastics have replaced glass and cork for floats; and nylon or terylene are becoming universal replacements for hemp rope. Losses in fishing gear are high, and in order to minimize these losses it is useful to be able to see floats and buoys clearly and at a distance. Oranges, yellows and reds provide the best visibility against the greens, blues, greys and browns of the sea. Nylon ropes are usually orange too, and all these brilliant, often fluorescent, spots of colour against the traditional black or brown of nets and lobster pots make most beautifully rich mosaics of colour.

I am looking now at the stern section of a fishing boat in a Cornish harbour, which is really a work of art in itself. The hull of the boat is basically blue, but has been splashed with bright green paint, while scrapes and scratches have revealed darker purple underpaint. The board over the side is greenish, with the under-

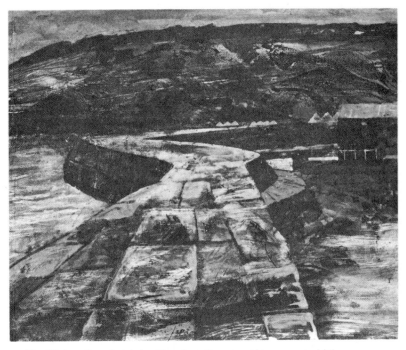

Fig. 72 Location sketch by Alan Jessett, watercolour, wax and ink

Fig. 73 Silkscreen print based on above

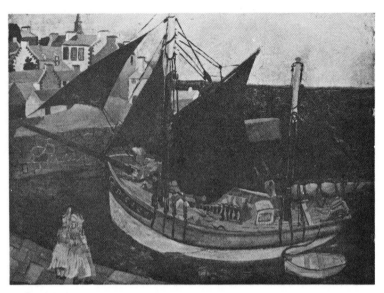
Fig. 74 *Boat in Harbour, Brittany* by Christopher Wood

painted orange showing through; the gunwales are light blue, the mast is orange, the nets are black, orange and blue with bright orange and pink floats.

There is a drawing of it in fig. 71, but you will have to take my word for the colour I'm afraid.

In any case these little cameos of colour and shape abound in fishing harbours, it is only necessary to be receptive to them. Vision is very selective; it has to be — it is a tool and a defence in life. If one is walking in a street or rocky shore, the brain through the eye is making myriads of calculations of scale and distance, compensating for perspective, sorting information into useful and non-useful categories, always from the point of view of the safe and efficient progress and balance of the individual. As artists we have to learn to look in a different way, objectively, seeing *apparent* shapes and sizes, without compensating. The simplest way I can explain the nature of this different vision is to ask you to imagine yourself approaching a small stream which you have to cross or jump. The mind, from the information given by the eye, will assess the width of the river and a judgement can be made about the possibilities of leaping it. Now to arrive at this judgement, calculations have been made, the distance to the stream edge has been assessed (not in precise terms but relatively), so that the allowance for perspective can be judged, the plane of the

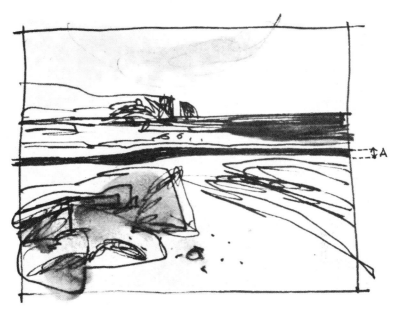

Fig. 75 Diagram of stream

ground which affects eye level and therefore relationship of apparent width of the stream to its real width has been noted, and probably also parallax effects (the apparent change in perspective between one viewpoint and another, head movement will produce it). It has all been automatic and almost instantaneous, but it is vital and very accurate. It is these sort of judgements which make the difference between life and death in a busy street.

Now let us stop and look at this stream again. Postpone the problem of crossing it, and just look at it. Measure its apparent width, i.e. its *depth* in a composition, A in fig. 75. Although one can know that it actually is quite wide, it is only a narrow little stripe relative to the foreground mass.

There is sea and cliff beyond. The shape of the sea might make a particular pattern with the curve of the stream, perhaps the edge of the cliff coincides with the widest part of the stream shape. Foreground rocks dwarf the far cliffs. Perhaps those cliffs and the dark shape of sea coupled with sweeping beach strata even make a stronger compositional element than the stream itself. The stream is then relegated to a secondary role in the overall beachscape.

While one was thinking of crossing it, it was *the* most important thing in one's vision, all attention was riveted on it and relevant surroundings, everything else was ignored. If asked to draw or

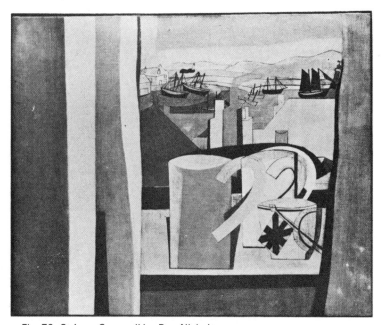

Fig. 76 *St Ives, Cornwall* by Ben Nicholson

Fig. 77 *Black Lion Wharf* by J. A. M. Whistler

Fig. 78 Seascape by Nicholas de Stael. Private Collection. Photo Arts Council of Great Britain and Courtauld Institute of Art

describe the shape of the skyline cliffs after this first observation, it would be found to be impossible, just as impossible as recalling the skyline shapes of buildings on a regularly crossed busy street. Yet the information entered the eye; it was sifted, considered irrelevant and therefore ignored.

For the objective painter it is the abstract, non-processed information which is essential — all the relationships and patterns of shape on shape, colour against colour, light and tone, texture, rhythm — all the things which are non-essential when making judgments related to action.

Realistic illusions of recession and depth can be created by use of perspective, tonal and colour changes etc., but abstract shape comes first. Of course, once having developed the capability of seeing the shapes and forms as they are, there is no reason why they should not then be stressed or changed or distorted, if it helps to make the statement clearer and more forceful.

In figs 72–3 are two interpretations of the same subject by a painter-illustrator friend of mine. The top drawing was more or less literal, although not entirely so (in fact I believe there was a previous drawing in which more factual detail was recorded).

Fig. 79 Boats at low tide, Ilfracombe

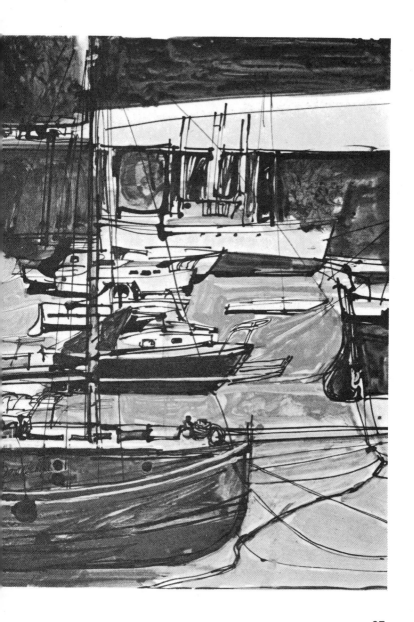

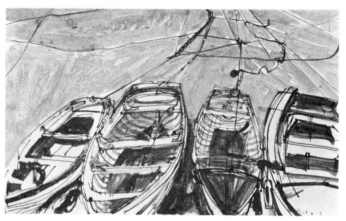

Fig. 80 Moored boats

A process of simplification, strengthening and rationalization then led to the lower picture. As you can see, it is not accurate in photographic terms. Or if it is, then the other one can't be. Indeed perhaps it shouldn't even be called by the name of the original harbour, yet despite its distortions the last picture has more of the intrinsic character of the place than the more 'accurate' one. I know this particular harbour well, and from the outermost arm of the sea wall on a sunny day there is a strong impression of clean sharp-edged whiteness, quite stark against the textured, rather rounded, hill behind. There are in fact houses and beach huts, roads and trees in the background, but they have all been left out. The fact that they were there is not sufficient reason to include them, if their inclusion would, as here, clutter the clear statement of harbour wall and sea against the simple land mass.

My drawings of boats in Ilfracombe harbour in figs 79–80, although fairly factual, have nevertheless stressed certain aspects of the reality so as to give greater importance to them than was perhaps the case in reality. In both it was the two-dimensional design that fascinated me — the pattern of solid shapes criss-crossed by masts, booms, rigging and mooring lines. In fig. 80 it is the geometrical design made on the sand by mooring ropes and chains that is the real subject, the boats themselves establish the scale and plane of the pattern.

There are four pictures by famous painters in this chapter, all depicting aspects of man's life by the shore, but all, as you can see, from very different points of view.

Christopher Wood's painting in fig. 74 shows that you don't necessarily have to be able to draw form and perspective realistically and accurately in order to produce a good picture. Indeed,

Fig. 81 Harbour, North Devon

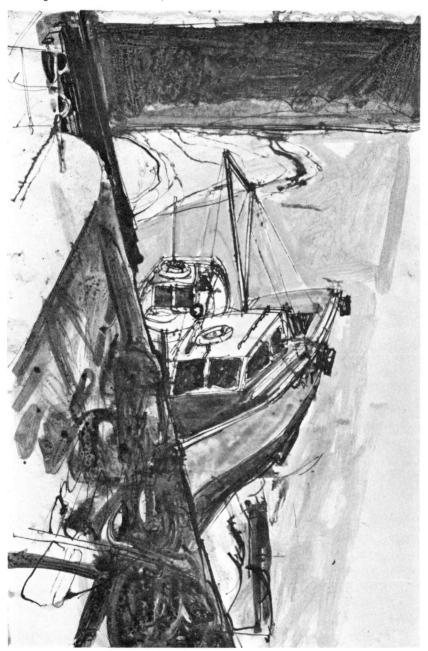

Fig. 82 On board ship

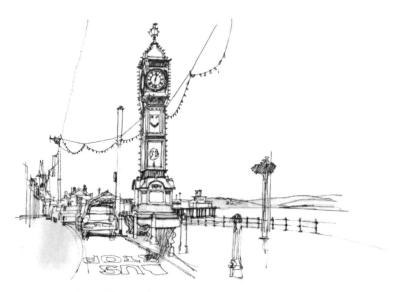

Fig. 83 Sea front, Weymouth

Fig. 84 Beach scene

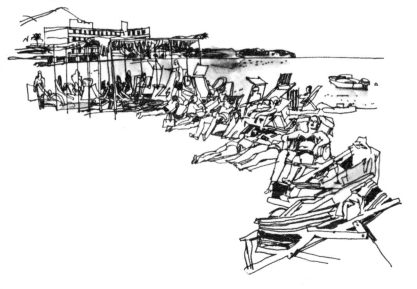

Fig. 85 Lobster pots

it is the almost childlike directness of imagery, uninhibited by the need for 'correct' scale and depth rendition, that gives his pictures their charm.

The De Stael (fig. 78) and the Ben Nicholson (fig. 76) are both sophisticated and stylish simplified statements, the former depending on absolute first-time directness and bold colour, the latter, calm, cool, thoughtful, lovingly textured.

Whistler's etching (fig. 77) is not strictly a marine picture, but a riverscape. However it does show what richness of texture and detail can be extracted from waterside impedimenta. No doubt a grey tone could have been laid down to represent the general colour of those warehouses, but it was clearly the subtly different textures of stone, tile and brick that interested him, so there was no alternative but painstakingly to draw them all in.

I would like to point out that this doesn't mean that De Stael by contrast is getting away with it, skating over the surface, so to speak. He was setting out to express something quite different, and the extreme simplicity may have been the final result of many, many attempts.

Figs 82–4 are drawings from my sketch book, which just touch on a series of subjects which could justify a book to themselves. It would seem that until now I have ignored the fact that the seaside is often teeming with human beings and the fabrications for their amusement. I don't mean to sneer: I just find that I have run out of room and time before getting around to this other, and for me I confess slightly less interesting, aspect of the sea.

Conclusion

I would like to make it clear that I do not put forward my own drawings and paintings as ends in themselves. They merely serve to make a point or two and represent a stage in my continuing, but far from final, observation of the sea. Be influenced, if you must, by the masters: then you should be able to do much better than I have.

You have, as an amateur painter, the big advantage of not having to show professional technical expertise. I think it futile and possibly damaging for a non-professional painter to try above all to acquire these skills.

Basic methods and organization of materials to minimize wasted time and effort, some perspective principles and colour theory are worth learning, but concentration of effort on acquiring a facile technique is likely to be self-defeating, in that what you will probably end up with is a set of superficial tricks, which get in the way of observation and expression.

A technique that fits what you have to say and how you want to say it, will come as long as you don't think about it too much.

Observation, resulting in discovery, is the number one requirement of objective painting, especially important when painting the sea, as there are so many overlaid preconceptions.

Next perhaps come simplicity and restraint, which do not, repeat not, exclude verve, audacity and strength. It just means that you should try to concentrate on *one* aspect of a subject, ruthlessly subordinating all elements which do not contribute to the total effect.

Lastly, be sure that you are interested in the subject. If you are not, your boredom will be obvious in your painting.

Index